IMAGES
of America

EARLY WALL STREET
1830–1940

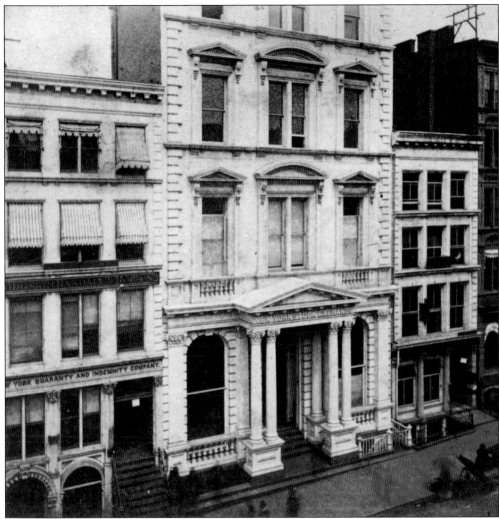

One of the rarest of the stereoviews issued by E. & H.T. Anthony & Co. shows the New York Stock Exchange, c. 1867, when the white marble of the facade was still pristine. Because of the long exposure times required for early photographs, moving figures show up as ghostly images. (Author's collection.)

ON THE COVER: Curb Market traders are transacting business in the middle of Broad Street in this stereoview. The traders worked outdoors in all kinds of weather; however, the shirtsleeves and straw hats would indicate that this photograph was taken on a warm day. The Curb Market moved indoors in 1921. (Author's collection.)

IMAGES
of America

EARLY WALL STREET
1830–1940

Jay Hoster

ARCADIA
PUBLISHING

Copyright © 2014 by Jay Hoster
ISBN 978-1-4671-2263-4

Published by Arcadia Publishing
Charleston, South Carolina

Printed in the United States of America

Library of Congress Control Number: 2014940115

For all general information, please contact Arcadia Publishing:
Telephone 843-853-2070
Fax 843-853-0044
E-mail sales@arcadiapublishing.com
For customer service and orders:
Toll-Free 1-888-313-2665

Visit us on the Internet at www.arcadiapublishing.com

CONTENTS

ACKNOWLEDGMENTS

Jeffrey T. Darbee read the text and made helpful suggestions. My thanks also go to Kristin Aguilera of the Museum of American Finance for giving me the opportunity to pursue my interest in this field within the pages of the museum's magazine *Financial History*. My wife, Genie, encouraged and supported this project every step of the way and for that I am deeply appreciative.

INTRODUCTION

The geography of Wall Street is compact, but its role in American life has always been immense. Perhaps nowhere are the demands of the present and the future so insistent as on Wall Street. Stock prices are relentlessly relayed around the globe, which are then parlayed into visions of the future, whether a glorious land of dreams fulfilled or a treacherous mire to be prudently avoided. And yet, Wall Street also goes back to an earlier time.

In 1621, the States-General, the legislative body of the Netherlands, made the colony of New Netherland a part of the West India Company. The past can protrude in seemingly unlikely places. Staten Island was named for the States-General, which is more evident when using the Dutch name, Staten-Generaal.

Peter Stuyvesant had fought the Spanish in the West Indies, and as director-general of New Netherland, he had an overriding concern in 1653—protecting the growing town of New Amsterdam from British forces expected to be coming south from New England. The result was a wooden stockade that was built across the northern edge of the city. In the 1660s, stone bastions where cannons could be placed were added. This was the wall that gave Wall Street its name.

When the British arrived in 1664, however, it was not by land but by sea, and instead of the bloodshed of war, the transition of power was more of the nature of a corporate takeover. The expansion of British power had been engineered by James, Duke of York, who would later become King James II. James also held the title of Duke of Albany, which afforded an additional opportunity to leave his name on the map.

It was not until 1699 that the wall was completely removed. The stone was repurposed in the building of a new city hall occupying a prime location on Wall Street at the head of Broad Street. In 1735, a case heard there made legal history when a printer named John Peter Zenger went on trial for libel. Zenger had printed within the pages of the *New York Weekly Journal* scathing critiques of the colonial governor, but his lawyer argued that truth was a sufficient defense against the charge of libel. The law did not actually say that, but the jury acquitted Zenger nevertheless.

The year 1776, which was so noteworthy for events in Philadelphia, was a harsh time in New York. A fire devastated the city, and while George Washington led his troops to victory in the Battle of Harlem Heights, continued British strength caused him to retreat to White Plains. The Battle of Yorktown is sometimes regarded as the end of the Revolutionary War, but the sequence of events it put into motion took time to play out. It was more than two years after Yorktown before the British left New York. On December 4, 1783, Washington said farewell to his officers at Fraunces Tavern.

When New York became the first capital of the United States, city hall was remodeled by Pierre Charles L'Enfant to become Federal Hall, and it was there that George Washington took the presidential oath of office on January 30, 1789.

The national capital moved to Philadelphia the following year. For Wall Street, the direction that the future would take was indicated by an event that took place on May 17, 1792, when 24

brokers signed an agreement setting a minimum commission rate and establishing a preference for dealing with each other. Legend has it that the document was signed beneath a buttonwood tree on Wall Street, giving it the name the Buttonwood Agreement, although Corre's Hotel has been put forth as a more likely venue.

Formal organization came in 1817 with the founding of the New York Stock & Exchange Board. The name was changed to the New York Stock Exchange in 1863, but it was not until 1865 that the organization had a building of its own. By then, other iconic structures that have defined Wall Street were in place.

The fire of 1776 left Trinity Church in ruins, and the second Trinity was damaged during the winter of 1838–1839. The building committee decided that the tower of the new building would line up exactly with the center of Wall Street. Richard Upjohn designed a church in the Gothic Revival style that continues to anchor the site at the head of Wall Street.

The location of Federal Hall eventually became the site of the US Custom House designed by Town & Davis in the Greek Revival style. The architects' plans called for a dome on the roof, which was never built. That left Alexander Jackson Davis disappointed, but for most people, the building's finishing touch was the installation of John Quincy Adams Ward's statue of George Washington, which was dedicated on a rainy day in November 1883, one hundred years after the British evacuation of New York.

At 55 Wall Street stands the second Merchants' Exchange, built following the fire of 1835. In the early 20th century, McKim, Mead & White added a second row of columns when it was converted to a bank headquarters from its prior use as the US Custom House.

In the 1860s, 23 Wall Street was a place to buy a meerschaum pipe, but that address was to become well known in financial history as the home of J.P. Morgan & Co. Change has continued at that site as well, as it is currently part of a condominium development named for a French architect.

All of the images in this book are from my collection and draw on a variety of sources. Many are stereoviews, which were published as a double image mounted on cardboard. They were popular in the latter half of the 19th century and into the 20th century because they produced a three-dimensional effect when viewed in a special holder. Today, their value to historians derives from the fact that the vast majority are actual photographs. A profusion of publishers issued stereoviews, but the favorite for many collectors is E. & H.T. Anthony & Co. Larger format cabinet photographs were able to present a wider view. An example is the photograph taken from Trinity's steeple that is on pages 24 and 25.

A few of the images in this book are steel engravings, which rendered scenes with precision but were expensive to produce, so popular publications of the day such as *Harper's Weekly* and *Frank Leslie's Illustrated Newspaper* relied on woodcuts. Pictorial postcards, which first became available in 1898, are another significant source of images. Collectors prize real-photo postcards because the images have not been retouched, and those published by Thaddeus Wilkerson are particularly sought after.

I hope you enjoy looking through these images as much as I have enjoyed collecting them.

One

THE BATTERY AND BOWLING GREEN

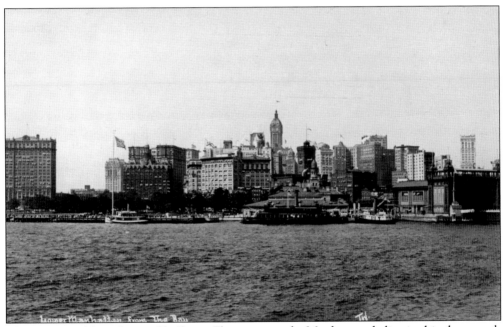

The Singer Building, designed by Ernest Flagg, crowns the Manhattan skyline in this photograph by Thaddeus Wilkerson, the master of the real-photo postcard. At 612 feet, it was the world's tallest building when the tower was completed in 1908. Six decades later, it was the tallest building ever to be demolished. Another structure that Flagg designed for the Singer Manufacturing Company, known as the Little Singer Building, is still standing at 561 Broadway.

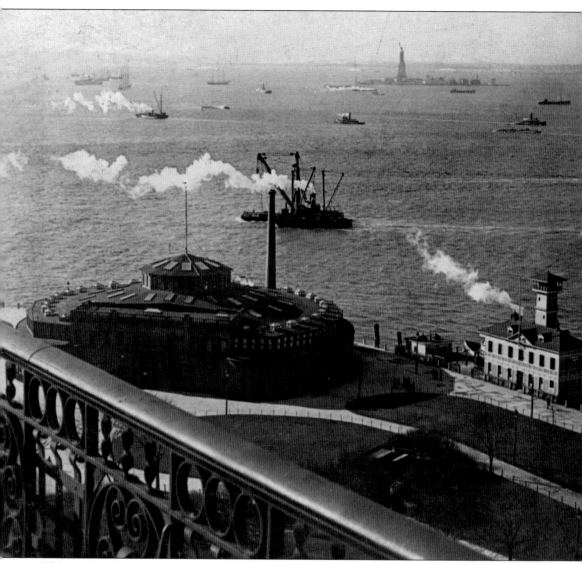

This early-20th-century stereoview shows Castle Garden at left. The original structure, dating from 1807, was a military fortification known as the West Battery. It was built in the bay and was connected to Battery Park by a bridge 90 paces long. It was renamed Castle Clinton in 1815 in honor of DeWitt Clinton. It was given the name Castle Garden when it was converted to civilian use in the 1820s. A remodeling project in 1845 added a roof, and it became a popular concert venue. In 1850, Castle Garden was filled to capacity to hear Swedish soprano Jenny Lind perform. P.T. Barnum had used all of his powers of promotion—and they were impressive—to create a superstar of the singer known to her fans as the "Swedish Nightingale." But there were changes in store for Castle Garden. From 1855 to 1890, it served as New York's processing center for newly arrived immigrants.

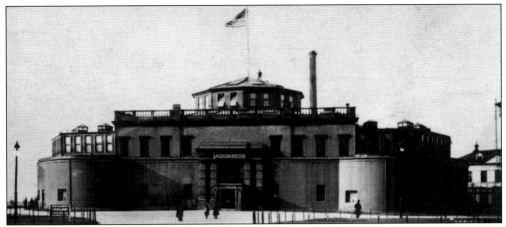

A remodeled Castle Garden became the site of the New York Aquarium, which opened in 1896. The process of adaptive reuse entailed installing the filtering plant in a former ammunition vault that had walls 15 feet thick. In other parts of the building, the walls were eight to nine feet thick. This real-photo postcard is dated 1906.

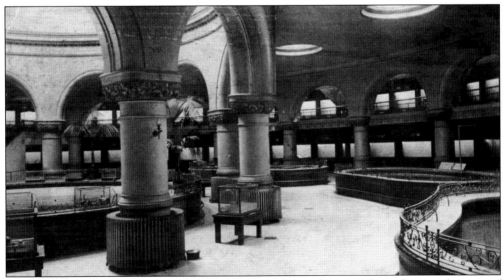

The New York Aquarium had 94 wall tanks, 25 smaller tanks, and 7 large floor pools, some of which can be seen in this view. The postcards on this page were issued by the New York Zoological Society, which took over management of the aquarium in 1902. The New York Aquarium closed at Battery Park in 1941, and a new facility opened at Coney Island in 1957. Today, the site is Castle Clinton National Monument.

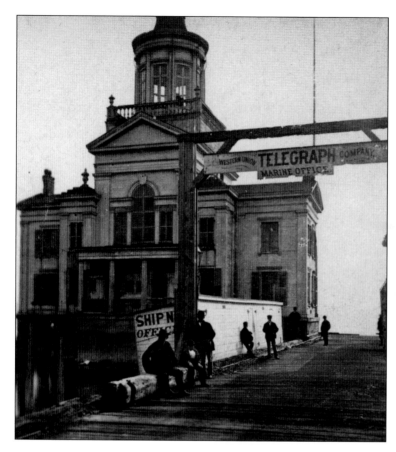

The first Barge Office was at the eastern end of Battery Park from 1845 to 1876. It housed a variety of government officials dealing with the shipping trade. The tower atop the building had a revolving light. Shipping information was an important element of business news, and reporters from the New York papers had space in the Ship News Office, which can be seen in front of the Barge Office.

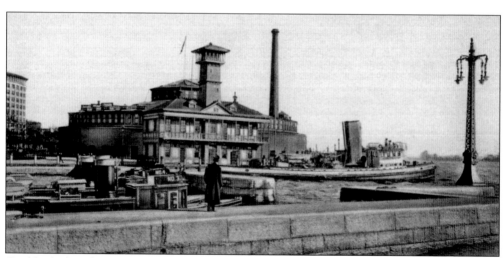

Could a fireboat be a movie star? The *New Yorker* demonstrated its capabilities in two short films released by the Edison Manufacturing Co. in 1903: *Fireboat "New Yorker" in Action* and *Fireboat "New Yorker" Answering an Alarm.* The fireboat's station was the two-story building with the watch tower that can be seen beyond the *New Yorker.*

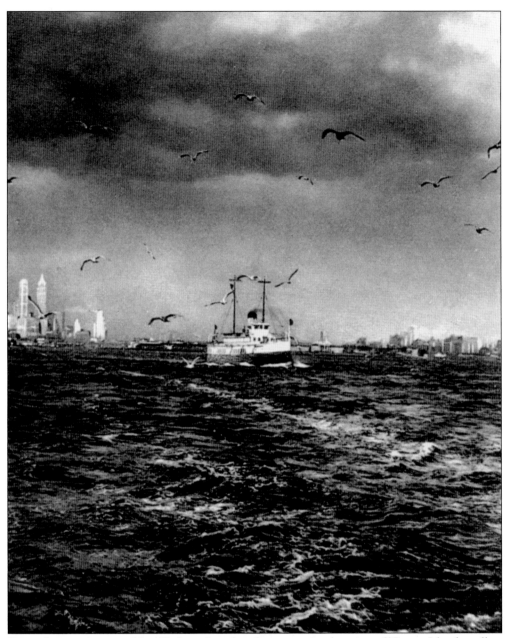

Ocean liners arriving in New York anchored at the quarantine location off Staten Island to allow health inspectors to examine the passengers for any evidence of disease. As that was occurring, the mail boat went out to the ship to pick up foreign mail being sent to the United States. In this postcard view from the 1930s, the tallest building is the 66-story Cities Service Building at 70 Pine Street, which was designed by the firm of Clinton & Russell, Holton & George and was completed in 1932. Cities Service also owned the building at 60 Wall Street, and a 16th-floor pedestrian bridge linking the two structures allowed the company to devise the address of 60 Wall Tower for the new structure, effectively bypassing the actual, but less prestigious, address on Pine Street. 70 Pine Street was the AIG Building from 1976 to 2008. To its left is the City Bank Farmers Trust Building at 20 Exchange Place. The mail boat service was discontinued in 1937.

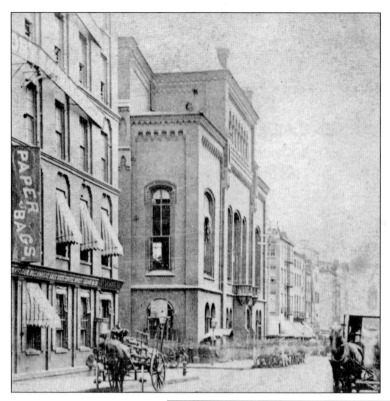

The Produce Exchange on Whitehall Street (at center) was designed by Leopold Eidlitz and was completed in 1861. After the Produce Exchange moved to a new building on Bowling Green, the US Army Building was constructed in the 1880s on the foundations of this structure. Bombed by protestors during the Vietnam War, it was partially demolished in the 1980s by a new owner, who then decided to save the building and use it as part of 3 New York Plaza.

South Ferry is in the foreground in this stereoview, and the Eidlitz-designed Produce Exchange is at the top, just right of center. On the street are two omnibuses. The omnibus was the urban version of a stagecoach and was known for its cramped quarters and jolting ride.

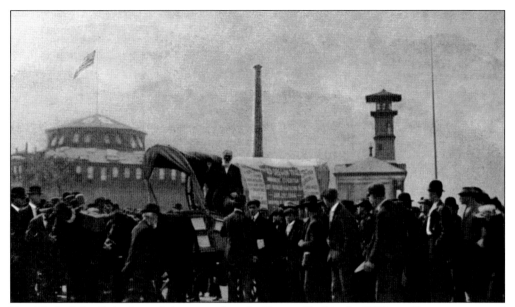

Ezra Meeker's family had traveled westward on the Oregon Trail in the 1850s, and he was concerned that its history was being forgotten. So in 1906, he embarked on a reenactment, traveling from west to east in a covered wagon pulled by two oxen. He arrived in New York in the summer of 1907. Meeker publicized his trip with a series of postcards, and in this view, Meeker is standing in his wagon facing a crowd of onlookers with Castle Garden in the background.

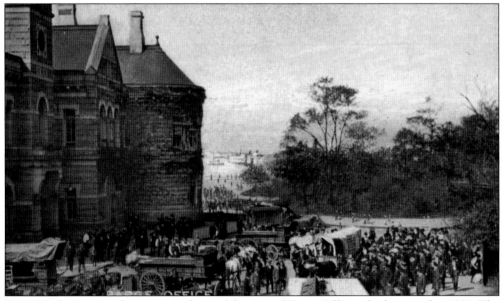

Here, Meeker's covered wagon is in front of the second Barge Office, which opened in 1883. The granite for the exterior had been brought to the site by a sloop of war. The Barge Office served as the immigrant processing center in the early 1890s. When a fire caused Ellis Island to be closed, it resumed that role from 1897 to 1900. The Barge Office was torn down in 1911.

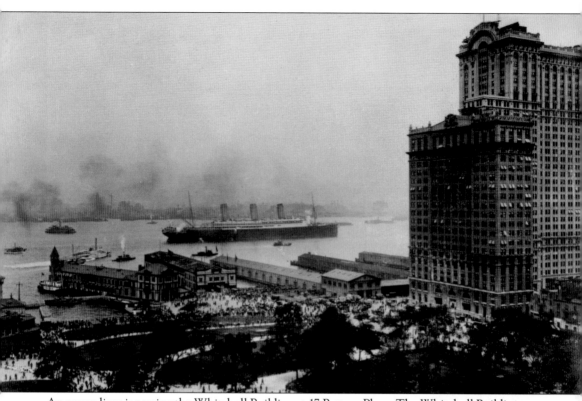

An ocean liner is passing the Whitehall Building at 17 Battery Place. The Whitehall Building was named for Peter Stuyvesant's 17th-century house and built by the Battery Place Realty Company, which was headed by William H. Chesebrough. In 1870, Chesebrough had created Vaseline Petroleum Jelly. The first section of the Whitehall Building was completed in 1903 and was designed by Henry J. Hardenbergh, who was also the architect of the Dakota Apartments and the Plaza Hotel. The 31-story addition, known as the Greater Whitehall, was designed by Clinton & Russell and was completed in 1911. It can be seen to the right, rising above the original building. The O'Rourke Engineering Construction Company was responsible for putting into place the pneumatic caissons of the foundation that played an essential role in the construction process.

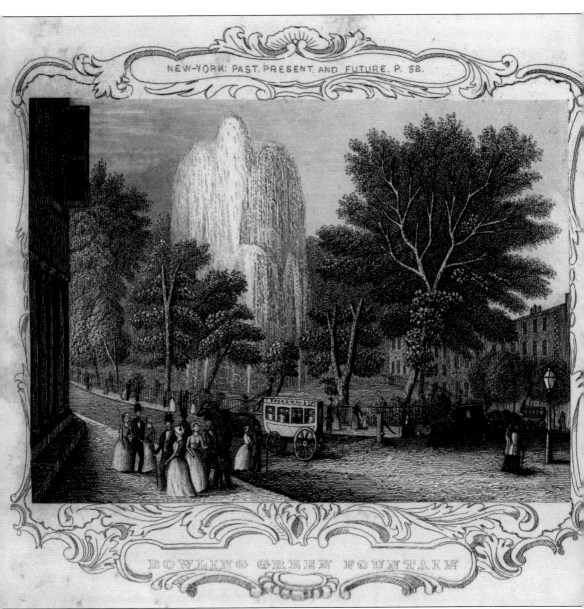

BOWLING GREEN FOUNTAIN

E. Porter Belden wrote a guidebook to the city titled *New-York: Past, Present, and Future*, published in 1849. This steel engraving in Belden's book shows the fountain in Bowling Green along with a group of well-dressed pedestrians and an ever-present Broadway omnibus. The cascading fountain was made possible by the Croton Aqueduct water system that brought a reliable supply of running water to New York beginning in 1842. Belden noted, "The jets are made to fall upon an uncouth mass of rocks which, in the opinion of some, gives to the scene a 'wild and picturesque appearance.'" Belden had another claim to fame for 19th-century New Yorkers. Leading a crew of "150 artists and artisans," he created a scale model of New York from the Battery up to Thirty-second Street along with part of Brooklyn that went on display in 1846 beneath an elaborately painted Gothic canopy. Although Belden's work attracted a great deal of attention when it was first presented to the public, the author of *The Columbia Historical Portrait of New York* (1953) was unsuccessful in finding out what happened to it.

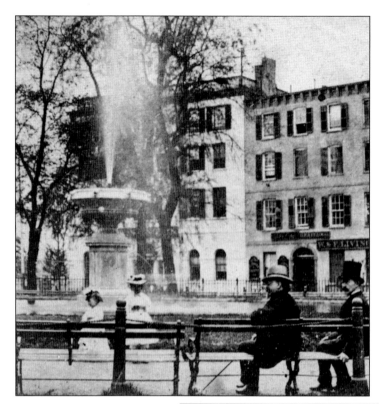

The Bowling Green fountain of the 1840s was a target of considerable criticism. Edgar Allan Poe commented that it had "much the air of a small country jail in a hard thunder shower." The city's decision to rebuild the fountain won the approval of the *Evening Post*, which commented that it would "present a more inviting aspect than the former gloomy attempt at rustic beauty." The new fountain is shown in this stereoview.

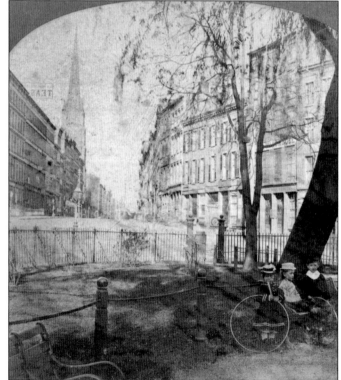

In this 19th-century stereoview, the northern end of Bowling Green was a quiet place for children taking a break from hoop rolling, a popular activity for young people that can be traced back to the ancient Greeks.

18

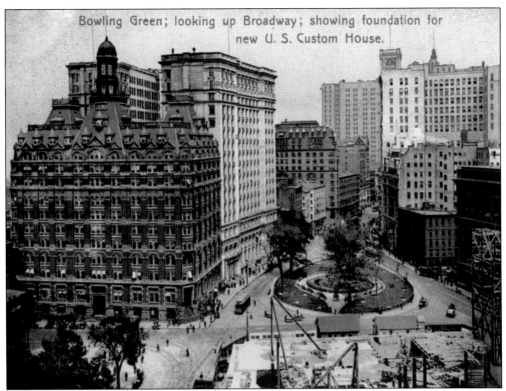

Bowling Green; looking up Broadway; showing foundation for new U. S. Custom House.

This postcard shows the construction site for the new US Custom House (in the foreground) and the Washington Building at 1 Broadway (at left). A refacing of the exterior of the Washington Building with limestone was completed in 1921. In the glory days of transatlantic ocean liners, travelers could book passage on the United States Lines at 1 Broadway. Cunard passengers went to the Great Hall of the Cunard Building at 25 Broadway.

The magnificence of Cass Gilbert's design for the US Custom House is shown in this Thaddeus Wilkerson real-photo postcard. The statuary includes representations of the continents, 12 city-states and nations noted for their role in commerce, and the shield of the United States. The building was completed in 1907. It now houses the National Museum of the American Indian-New York and the US Bankruptcy Court for the Southern District of New York.

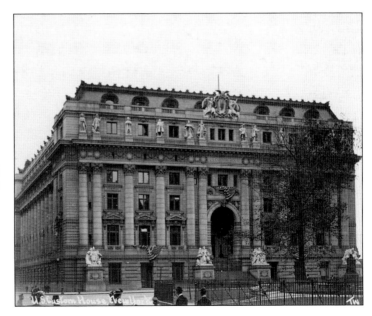

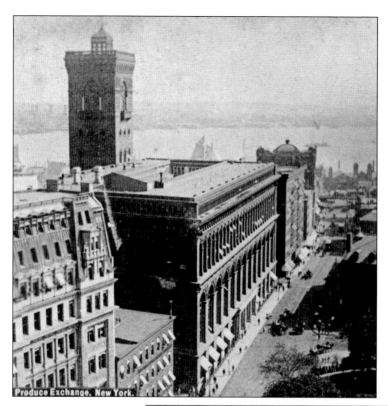

Produce Exchange, New York.

George B. Post won a design competition for the new Produce Exchange that was built at 2 Broadway facing Bowling Green. It was completed in 1884. The Romanesque arches of Post's design become successively more tightly grouped together in the building's elevation, drawing the viewer's attention upward to the tower surmounting the building. The building at left is the Seaboard National Bank.

The main hall of the Produce Exchange, shown here, was 144 feet wide by 220 feet long. The skylight that ran the length of the room was 60 feet above the floor. Four thousand drawings had been used in the building's construction. The flag above the building was 20 feet by 50 feet, which at the time was the largest ever made. The Produce Exchange was demolished in 1957.

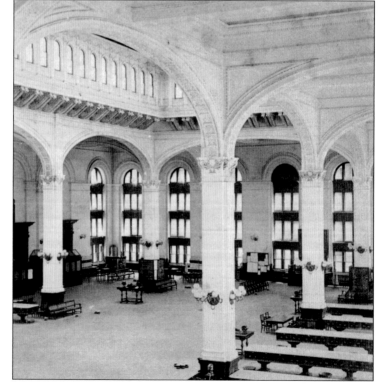

The Standard Oil Building at 26 Broadway (at left of center) is decked out in patriotic bunting. To its right are the Seaboard National Bank (1881) and the Produce Exchange Bank (1905), which was designed by Ernest Flagg, the architect of the Singer Building. One of the pieces of statuary in front of the US Custom House is at the right, and at the bottom is the roof of a subway kiosk.

The Cunard Building at 25 Broadway overlooks Bowling Green with a stately limestone-clad presence, but its true glory is the richly decorated Great Hall with its murals depicting great explorers and a map showing Cunard routes. In later years, the Great Hall housed a post office. The building was designed by Benjamin Wistar Morris with Carrère and Hastings and was completed in 1921.

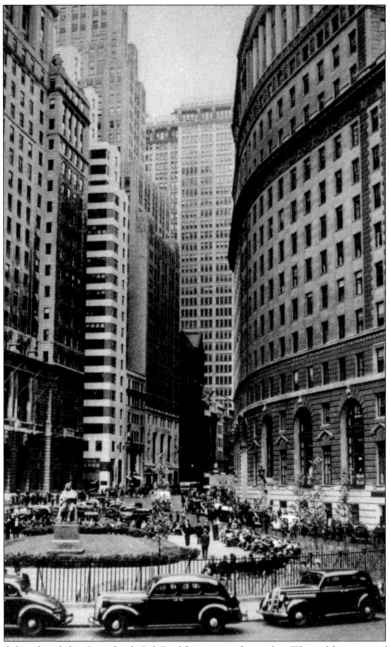

The curved facade of the Standard Oil Building is at the right. The addition to the original building was designed by Thomas Hastings of Carrère and Hastings with Shreve, Lamb & Blake as associated architects. Most of the construction took place between 1921 and 1926, but the project could not be completed until 1928, following the expiration of the lease held by a restaurant on Beaver Street that had been a holdout. The Cunard Building is across the park from the Standard Oil Building, and to its right is 29 Broadway with its prominent horizontal elements. The Adams Express Building is in the distance at the center. The statue of Abraham de Peyster, a mayor of New York in the 1690s, is at the southern end of the park. The statue's subsequent travels have led to its current location in Thomas Paine Park.

Two

TRINITY AND BROADWAY

The first Trinity Church was destroyed in the fire of 1776. The second was damaged during the winter of 1838–1839. After the fire and the snow, a masterpiece emerged. Richard Upjohn's Gothic Revival church was completed in 1846, and for many years, its spire was the city's tallest landmark. In this real-photo postcard, Bruce Price's American Surety Building at 100 Broadway (1896) is seen in the background.

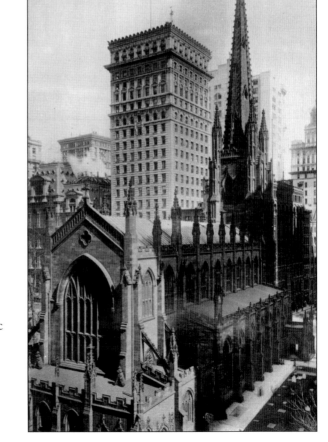

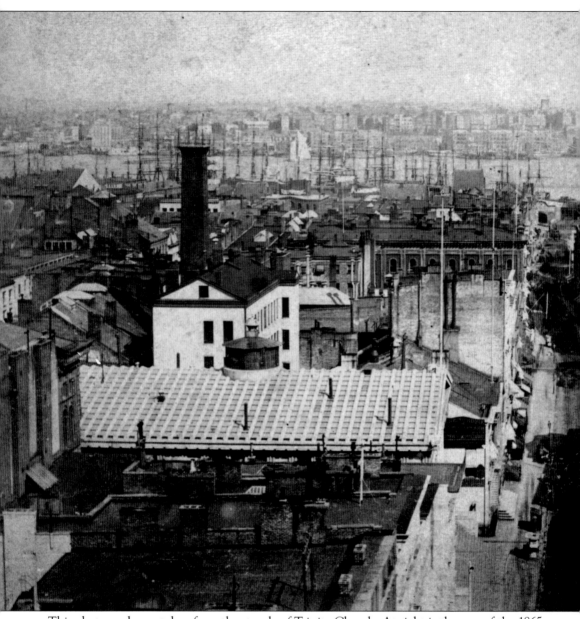

This photograph was taken from the steeple of Trinity Church. At right is the rear of the 1865 New York Stock Exchange building. The roof of the Sub-Treasury Building can be seen at the left, and beyond it is the tall chimney of the US Assay Office. The dome of the US Custom House at

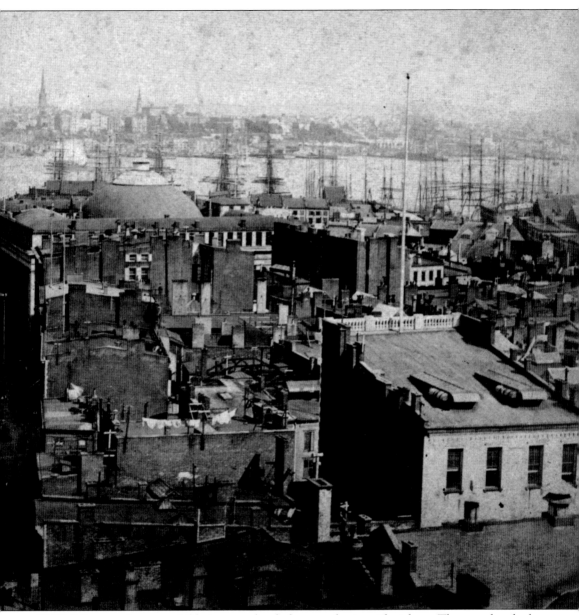

55 Wall Street, often not visible in street-level photographs, is evident here. The round-arched windows and cornice of the Bank of New York can be seen across the street from the US Custom House. Sailing ships are moored at East River piers, and Brooklyn is in the distance.

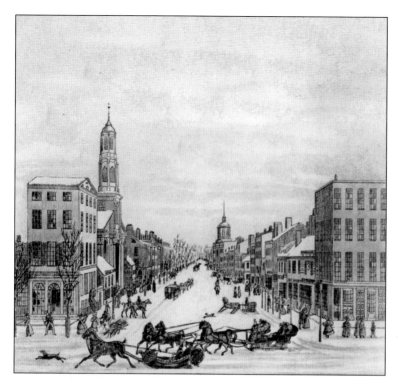

This is what an observer would have seen in 1834 while standing in front of Trinity Church and looking down Wall Street. Lithographer Peter Maverick Jr. printed the original artwork. This reproduction was sent as a holiday card in 1928 by the brokerage firm Samuel Ungerleider & Co. The steeple of the First Presbyterian Church is at the left, and the first Merchants' Exchange can be seen in the distance.

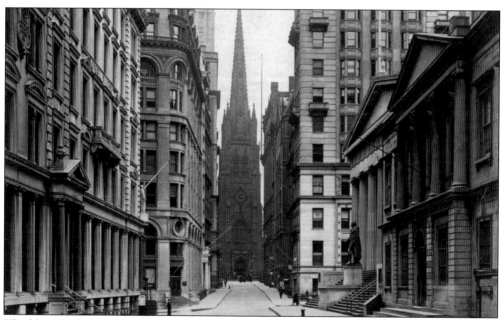

Thaddeus Wilkerson rendered the standard postcard view of Wall Street with precision. The columns of the US Assay Office (at right) are across the street from a pedimented entryway of the J.P. Morgan & Co. Building (at left). This photograph was taken prior to the demolition of the Gillender Building in 1910, which can be seen in the middle background at right of center.

A stereoview photograph taken from the Trinity steeple shows the neighborhood west of the church and includes shipping on the Hudson River. A commercial structure with a mansard roof (at right), a style that was popular from the 1860s into the 1880s, exists in close proximity to residential buildings, which can be identified by rooftop laundry set out on clotheslines.

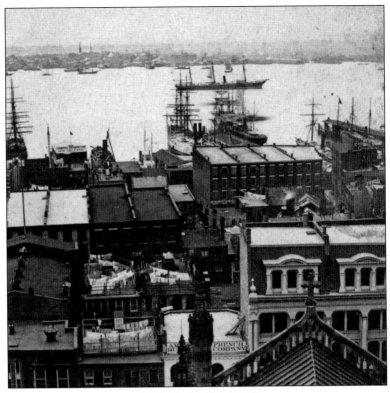

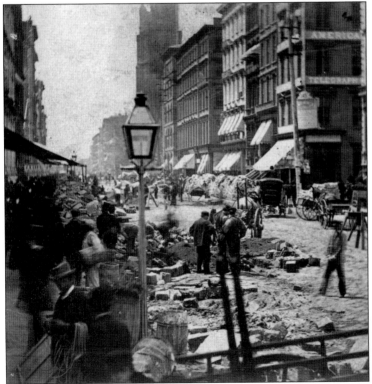

The city began replacing cobblestones with Belgian blocks in the mid-19th century. The rectangular shape of the Belgian blocks provided a smoother surface than the rounded cobblestones. Here, a horse-drawn cart is delivering a load of blocks for the paving of Broadway. Trinity can be seen in the background.

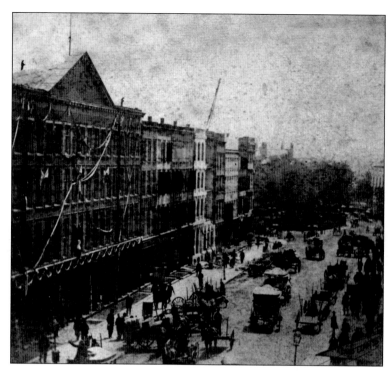

Pres. Abraham Lincoln's body lay in state at city hall on April 24 and 25, 1865. The *New York Herald* reported that "from the Battery to Union Square there was not a building but assumed, in some shape or other, the garb of sorrow." The cloth placed on the Exchange Court Building at the southeast corner of Broadway and Exchange Place (at left) was an indication of mourning.

A new Exchange Court Building, designed by Clinton & Russell, was completed in 1898. This was a U-shaped, 12-story building. Note the bear and bull figures alongside the arched entryway on Exchange Place. In the early 1980s, the building was expanded upward and refaced with a metal-and-glass curtain wall.

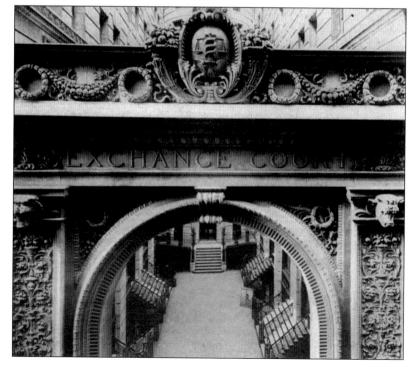

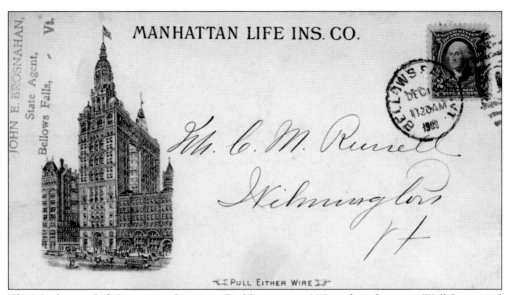

MANHATTAN LIFE INS. CO.

Mr. C. M. Russell Wilmington Vt

⊏ PULL EITHER WIRE ⊐

The Manhattan Life Insurance Company Building was at 66 Broadway between Wall Street and Exchange Place. It was designed by Kimball & Thompson and completed in 1894. This envelope shows that the building was a point of pride for the company. It was demolished in the 1960s for an expansion to the Irving Trust Building at 1 Wall Street.

The Tower Building (at right) was designed by Bradford Lee Gilbert and completed in 1889. It rose 11 stories and was the first building in New York to use skeleton framing in its construction. The architect had his office on the top floor. The Consolidated Stock Exchange is at the center with the Manhattan Life Insurance Company Building rising above it.

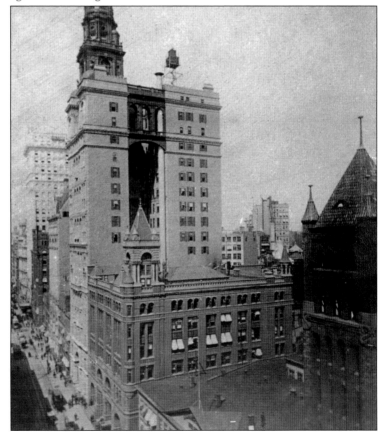

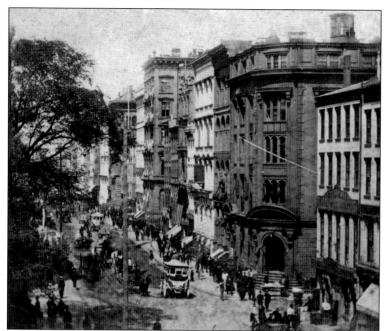

The Bank of the Republic Building at the northeast corner of Broadway and Wall Street was designed by Hurry & Rogers and completed in 1852. The Italianate design marked a transition from the Greek Revival architecture that earlier had been predominant. The entryway was set at a diagonal to the intersection and was marked by a prominent round pediment.

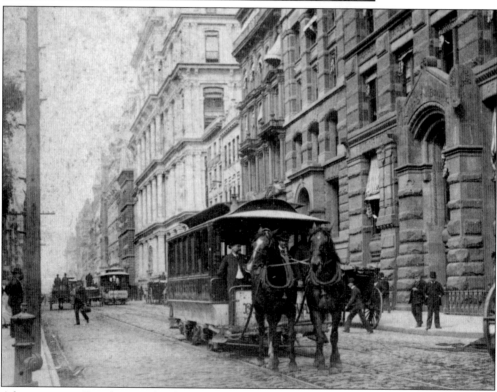

A horsecar is on Broadway, and at the right is the United Bank Building, which replaced the earlier structure at Broadway and Wall Street. Owned jointly by the National Bank of the Republic and the First National Bank, the United Bank Building was designed by Peabody & Stearns and was completed in 1880. The first Equitable Building is in the background.

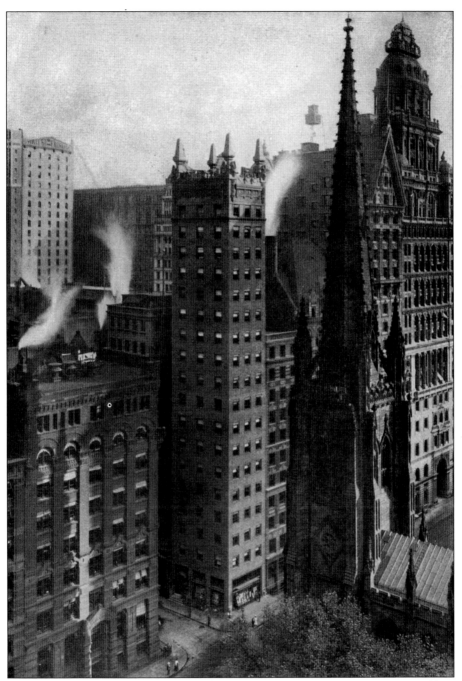

One of the oddest structures ever built in the financial district was the Chimney Building at 1 Wall Street. Designed by Barnett, Hayner & Barnett and completed in 1907, it was a brick tower of spartan design with some unexpected ornamentation at the top. Each corner was adorned with an object that resembled an oversized lampshade finial. What was remarkable about the Chimney Building was clearly not the architecture, but the high price of the land for a site that extended only 29 feet, 10 inches on Broadway and 39 feet, 10 inches on Wall Street. Constructing an 18-story building on such a small site entailed a design that used compact elevators.

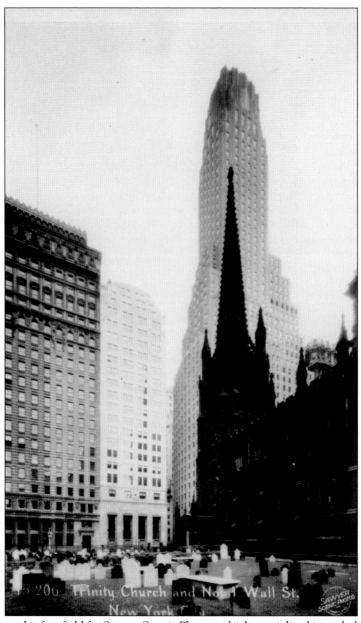

5 206 Trinity Church and No. 1 Wall St.
New York City

Wall Street was a bit far afield for Sawyer Scenic Photos, which specialized in real-photo postcards of the Pacific Northwest, but the photographer found just the right camera angle to pose the spire of Trinity Church against the background of the Irving Trust building at 1 Wall Street. The building was designed by Ralph Walker of Voorhees, Gmelin & Walker and was completed in 1931. Just about any new structure would have been an improvement on the Chimney Building, but Walker created an Art Deco masterpiece rendered in limestone. On the northwest corner of Broadway and Wall Street is the First National Bank Building at 2 Wall Street (1933), designed by Walker & Gillette. To its left, the American Surety Building is undergoing a cleaning. The Bank of New York moved to 1 Wall Street after acquiring Irving Trust in 1988, and a merger with Mellon Financial Corporation led to the creation of Bank of New York (BNY) Mellon in 2007. In 2014, BNY Mellon sold the building to a joint venture led by Macklowe Properties.

The commercial buildings on Broadway just south of Trinity Church are seen in this stereoview. The Empire Building is currently on this site. Elisha Graves Otis played an important role in the transformation of New York from a city of walk-up buildings. Otis invented the safety brake for elevators and gave a convincing demonstration at the Crystal Palace Exhibition in 1853.

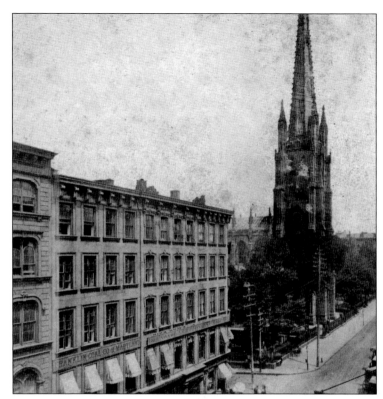

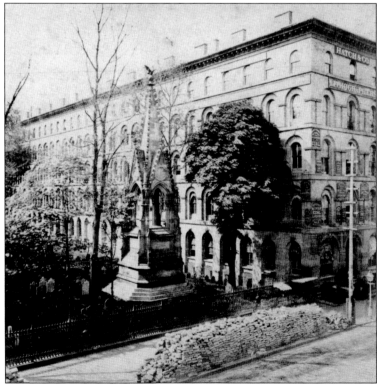

The five-story Trinity Building, completed in 1852, was designed by Richard Upjohn, the architect of Trinity Church. Upjohn had his office in the building. The Soldiers' Monument (also known as the Martyrs' Monument) in Trinity churchyard honors American soldiers who endured harsh conditions as prisoners during the Revolutionary War. Note the Belgian blocks on the sidewalk waiting to be laid on Broadway.

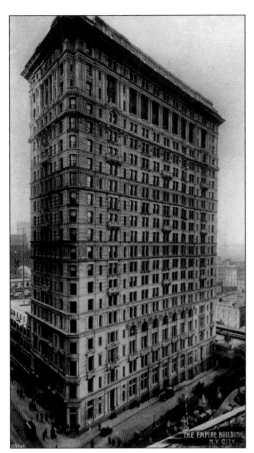

The Empire Building is one of the bookend buildings elegantly enclosing Trinity churchyard. It was designed by Kimball & Thompson and was completed in 1898. The architects placed the elevators and corridors on the southern side of the building so that the northern side with its views of the churchyard would consist entirely of offices.

The Trinity Building is the bookend structure to the north of Trinity churchyard. Designed by Francis Hatch Kimball, it was completed in 1905 and replaced Richard Upjohn's Trinity Building. Kimball showed respect for the site, which included the Soldiers' Monument in close proximity.

Kimball also designed the US Realty Building just to the north of the Trinity Building. It was named for the firm that was the developer of both buildings. During the construction of the US Realty Building (1906–1907), Kimball added a cupola to the Trinity Building, and in 1912, a walkway linking the two structures was built over Thames Street.

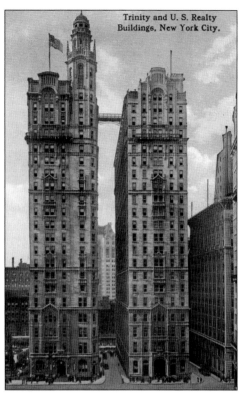

Trinity and U. S. Realty Buildings, New York City.

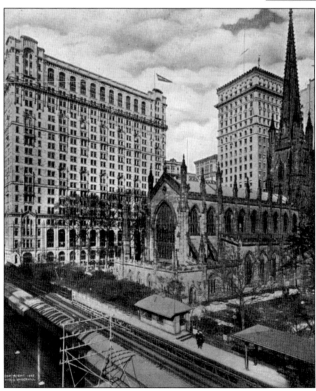

Trinity churchyard has long served as a peaceful haven amidst the clamor of the city, although that has not always been the case. From the 1870s until 1938, opportunities for quiet contemplation and relaxation were punctuated by the noise of the Sixth Avenue elevated train that ran above Trinity Place just behind the church.

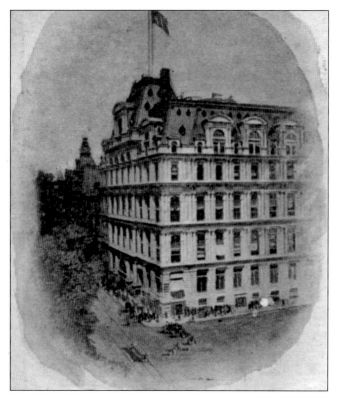

Gilman & Kendall won a design competition for the headquarters building of the Equitable Life Assurance Society at 120 Broadway. It was completed in 1870. George B. Post's entry was not selected, but he was given responsibility for the building's ironwork and elevators and later designed an addition to the structure. This postcard was sent to Hungary in 1901, and thanks to an online transaction, it came back to the United States 112 years later.

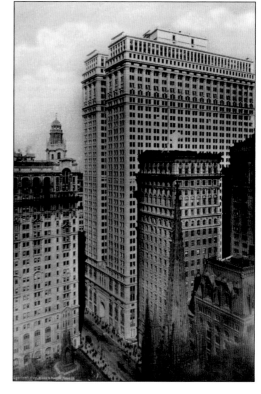

Seen here in a real-photo postcard, the second Equitable Building towers over the American Surety Building (at right of center) and the Trinity Building (at left). The structure, with 1.2 million square feet of rentable space, was completed in 1915 before a new zoning law became effective that required setbacks on tall buildings.

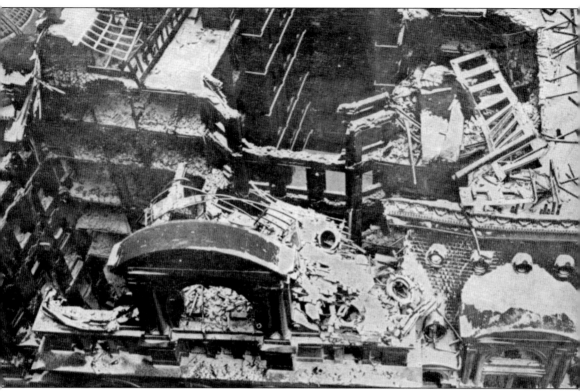

On the morning of January 9, 1912, a fire started in Café Savarin in the basement of the Equitable Building. Employees thought, wrongly, that they could contain it. It was a bitterly cold day, and water from the fire hoses left the building sheathed in a thick layer of ice. Postcards were rushed into print to document the Equitable Building fire. This view shows the ruins of the building from above. It includes the arch on the top floor and the remains of the mansard roof. Six people died in the fire, including fire battalion chief William Walsh, who led 14 firefighters into the building to search for survivors. All 14 got out safely, but Walsh did not. Walsh had a reputation in the department for never sending a firefighter in where he himself would not go. The *New York Times* reported that when a former fire chief learned of Walsh's death, he shook his head with sadness and said with admiration, "He was a fireman."

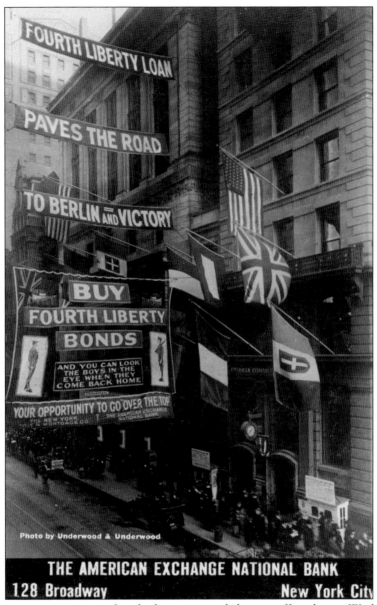

FOURTH LIBERTY LOAN

PAVES THE ROAD

TO BERLIN AND VICTORY

BUY
FOURTH LIBERTY
BONDS

AND YOU CAN LOOK
THE BOYS IN THE
EYE WHEN THEY
COME BACK HOME

YOUR OPPORTUNITY TO GO OVER THE TOP

THE NEW YORK
TITLE & MORTGAGE CO.

THE AMERICAN EXCHANGE
NATIONAL BANK

Photo by Underwood & Underwood

THE AMERICAN EXCHANGE NATIONAL BANK
128 Broadway New York City

Liberty Loans were government bonds that supported the war effort during World War I. To encourage public interest, they were heavily promoted. The fourth Liberty Loan series was issued on September 28, 1918, and offered bonds totaling $6 billion. This banner at the American Exchange National Bank at 128 Broadway presented a provocative message: "Buy Fourth Liberty Bonds and you can look the boys in the eye when they come back home." The flags of the Allies are arrayed on the front of the building. In the 1960s, it became part of the site of 140 Broadway, a sleek modernist citadel clad in aluminum and glass that was designed by Gordon Bunshaft of Skidmore, Owings & Merrill. The plaza in front of 140 Broadway has a monument honoring developer Harry B. Helmsley and Isamu Noguchi's sculpture *Red Cube*. The Landmarks Preservation Commission's designation report noted that the color of the sculpture is actually vermilion, and the shape is something called a rhombohedron. Asking passersby for directions to the vermilion rhombohedron would no doubt elicit a variety of interesting responses.

Three

THE NEW YORK STOCK EXCHANGE AND THE CURB

STOCK BROKER'S OFFICE,
No, 16, WALL-STREET.

THE subscriber has removed his office from No. 45, G. Dock-street, to No. 16, Wall-steeet, five doors up from Queen-street, where he purchases and sells all kinds of Stock on commission as usual.

Orders from any part of the United States, will be received with thankfulness, and executed with all possible dispatch,

LEONARD BLEECKER.

New-York, 3d August, 1792.

Leonard Bleecker's signature heads the list of the brokers who signed the Buttonwood Agreement, which laid the groundwork for the subsequent creation of the New York Stock Exchange. This advertisement appeared in the September 24, 1792, issue of a New York newspaper called the *Diary, or Loudon's Register.*

Founded as the New York Stock & Exchange Board in 1817, the New York Stock Exchange (NYSE) adopted its current name in 1863. Two years later, the organization moved into a building designed by John Kellum that had a facade of white marble and a portico with Corinthian columns facing Broad Street. The *New York Herald* wrote that "a wide staircase leads to the second story, in the rear of which is a room in which the business of the board will henceforward be transacted. This room is very handsomely furnished with about three hundred black walnut upholstered chairs, with a black walnut rostrum, and a large table of the same material." This c. 1867 E. & H.T. Anthony & Co. stereoview included the building at 23 Wall Street that had a store selling meerschaum pipes on the ground floor. A shutter is askew on the fourth floor. For later images of 23 Wall Street and the New York Stock Exchange, see pages 47 and 53.

E. & H.T. Anthony & Co. titled this stereoview "The Bulls and Bears of the Open Board." In the late 1860s, the Open Board of Brokers offered a serious challenge to the New York Stock Exchange. The Open Board had more lenient entry requirements and featured continuous trading in stocks. In 1869, it merged with the NYSE.

Frank Leslie's Illustrated Newspaper showed its readers the interior of the New York Stock Exchange in 1865. Stocks were called one at a time, and while some members stood, others remained in their seats. The NYSE went to continuous trading in 1871, although a membership in the organization is still referred to as a "seat."

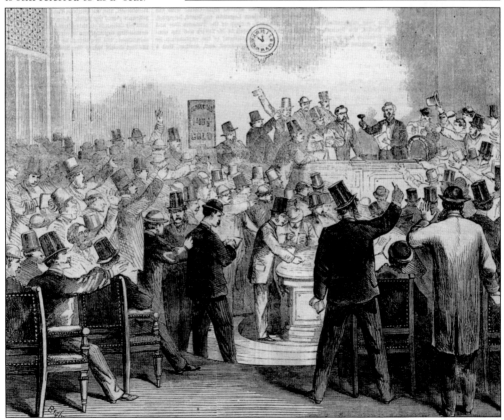

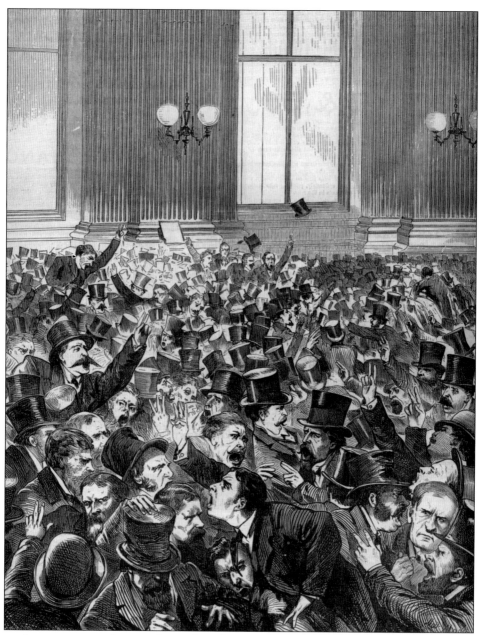

It was front-page news whenever the stock market went haywire. *Frank Leslie's Illustrated Newspaper* brought this scene to its readers in 1872. A buying frenzy was created in the stock of the Erie Railroad Company following the ouster of Jay Gould as the company's president. The paper noted the following about investors: "[They] acted as if they were insane, and had lost all restraint. If the vicinity of the Stock Exchange is a busy one ordinarily, the scene then was beyond description. Even age was not proof against the infection. Gray-headed men rushed from the Exchange to their offices, and from their offices back to the Exchange, in common with the boys who act as messengers for the brokers. Time never in their eyes had the value that it possessed then to them. A moment gained was a fortune won. Omnibuses, hacks, drays, trucks, wagons, were utterly disregarded. People ran under the horses, and narrowly escaped."

When all else was madness, the telegraph operator on the floor of the New York Stock Exchange remained calm as he transmitted stock prices. *Frank Leslie's Illustrated Newspaper* noted, "He carries his instrument on his arm, as a conductor does his lantern. The connection between the wires and the instrument is by means of a flexible wire, which gives the operator freedom to move about near the presiding officer's desk. He wears a straight-brimmed hat, and has a sphinx-like countenance."

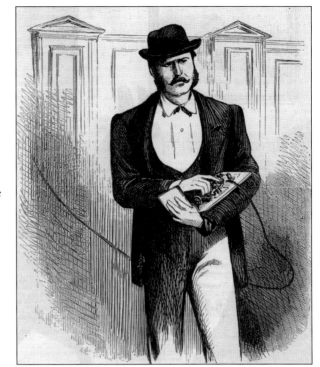

In the midst of the chaos, messengers were trying to catch the attention of their employers on the floor of the exchange.

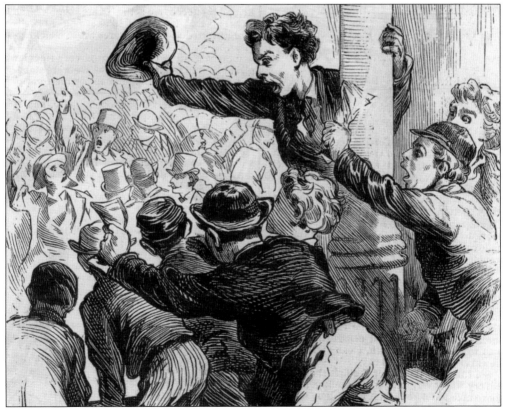

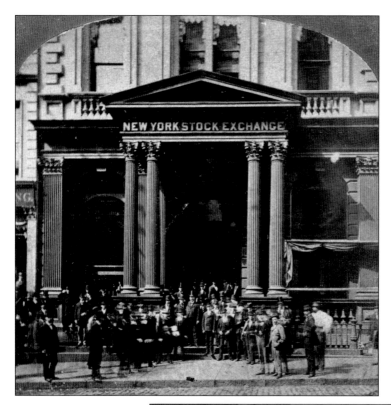

The surest way to gauge the status of people associated with the New York Stock Exchange in this stereoview is through their headwear. The marble of the portico is markedly dirtier than in earlier views.

The dinginess of the portico of the New York Stock Exchange is also evident in this stereoview that looks north toward Wall Street. A telegraph company occupies the ground floor of the building directly to the north of the NYSE, and there are telegraph poles on the roof.

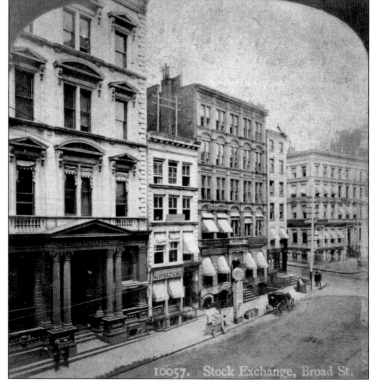

10057. Stock Exchange, Broad St.

The partnership between the Drexel family of Philadelphia and J.P. Morgan made a statement with their headquarters building at 23 Wall Street. Completed in 1873, the Drexel, Morgan & Co. Building had a white Vermont marble exterior and a mansard roof. Although in later years Morgan would come to dominate American finance and play a pivotal role in resolving the Panic of 1907, at this point in his career, he received second billing to the Drexels.

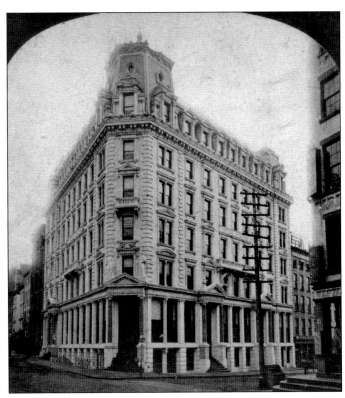

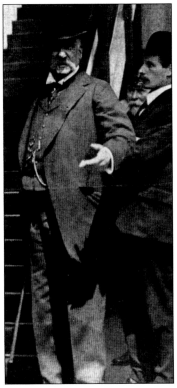

Morgan put together a shipping trust, the International Mercantile Marine Company, which included the White Star Line and shipbuilder Harland & Wolff. This view shows him at the launching of the *Titanic* in Belfast in 1911, displaying his customary frustration in dealing with the press. The men at right are unidentified.

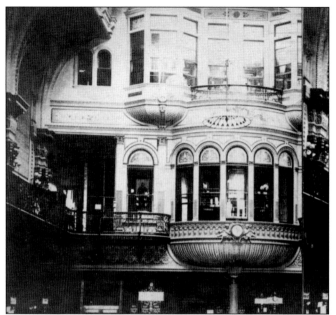

This interior photograph of the New York Stock Exchange's 1881 building shows the decorative railing of the visitors' gallery that overlooked the trading floor.

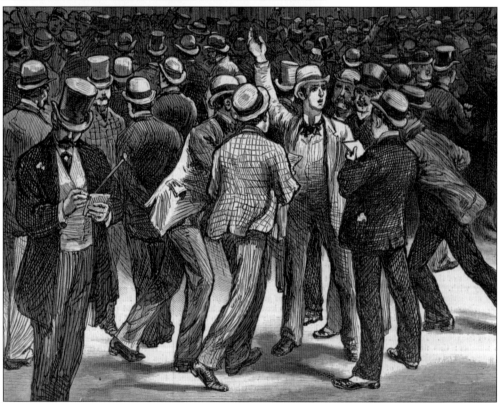

An artist for *Harper's Weekly* depicted a transaction taking place on the floor of the NYSE, but the paper admitted that something was necessarily missing: the noise level. "Visitors lean over from the galleries and wonder at the tumult below. They cannot catch a word that is said, nor can they see a reason for the tumult."

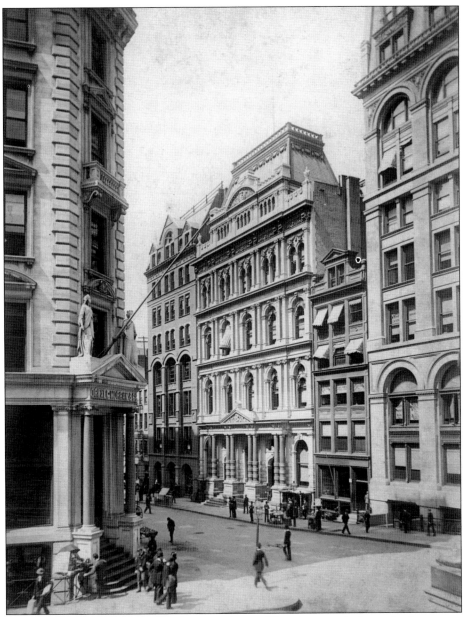

The changes from the view on page 40 are significant. This photograph shows the front entrance of the Drexel, Morgan & Co. Building at 23 Wall Street (at left) and the enlarged and redesigned New York Stock Exchange (at center). The NYSE's original building had been expanded in 1871, but an increasing membership and the demands of technology dictated an even larger space. *Harper's Weekly* noted that the building "was not large enough to accommodate the hundreds of telephones, telegraph instruments, and 'tickers' that have so multiplied within the last ten years." James Renwick Jr., one of the foremost architects of the day, was given the assignment of enlarging and remodeling the existing building. *Harper's Weekly* noted the following of his design: "The front is of marble, elaborately carved in the French Renaissance style. The portico of the first story has eight polished and carved red granite columns flanking the three windows and two doors." Renwick's building opened in 1881. For a later view of this scene, see page 53.

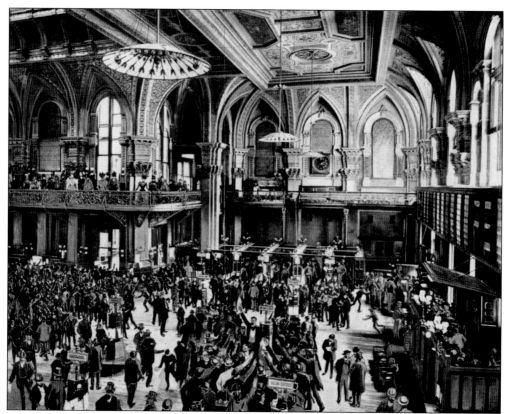

Renwick chose a Gothic style for the interior of the New York Stock Exchange. The 35-foot-high pillars had marble bases and bronze capitals, and the vaulting above them rose an additional 20 feet to the ceiling. *Harper's Weekly* approved and said, "The effect is good, for there is the appearance of strength and gracefulness combined. At each end of the room is a gallery, from which visitors can look down upon the conflicts between bulls and bears in the arena below." The Victorian color palette employed in public spaces was more exuberant than what people are accustomed to today, and *Harper's Weekly* noted, "The walls and ceilings are painted in the richest and most elaborate style of Renaissance decoration. Blue and gold are the predominating colors, but by no means the only colors; for in painting the arabesques of flowers and foliage, and the fabulous beasts of the Renaissance, all the colors of the rainbow are used, and some not in the ordinary every-day rainbow." This view was published in E. Idell Zeisloft's *The New Metropolis* (1899).

Renwick's building was in use for only two decades. This photograph was taken on April 28, 1901, the last day the building was open. For the next two years, the New York Stock Exchange operated from space in the Produce Exchange while a new building designed by George B. Post was under construction.

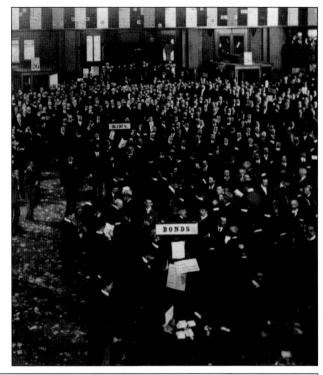

The foundation of the new building used caissons that were driven down to bedrock, which was about 60 feet below street level. The caissons linked together to form a continuous concrete masonry wall and are shown on this plan as rectangles. Most were eight feet in width. They varied in length from 24 feet to over 30 feet. Cylindrical caissons were also used, which are shown on the plan as circles.

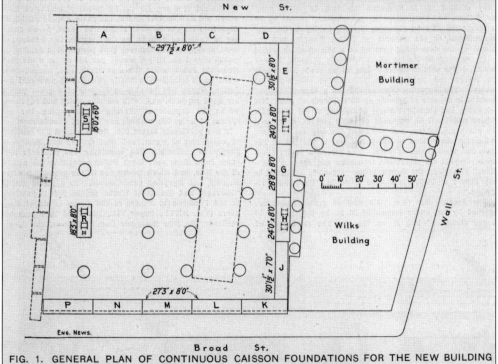

FIG. 1. GENERAL PLAN OF CONTINUOUS CAISSON FOUNDATIONS FOR THE NEW BUILDING OF THE NEW YORK STOCK EXCHANGE.
George B. Post, Architect; John F. O'Rourke, M. Am. Soc. C. E., Engineer and Contractor for Foundation Work.

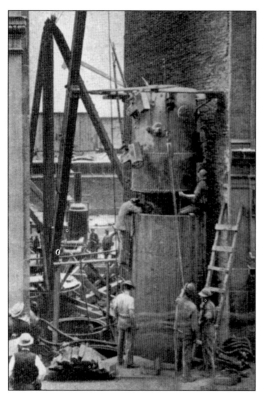

Workers are preparing the cylindrical caissons that form part of the foundation of the Wall Street entrance to the New York Stock Exchange's new building. This portion of the site is shown on the plan as two circles at the end of the narrow extension to Wall Street.

This view of the foundation work at the New York Stock Exchange site looks east toward Broad Street. In the background are the J.P. Morgan & Co. Building at 23 Wall Street (at left) and the Mills Building with its arched entrance (at right).

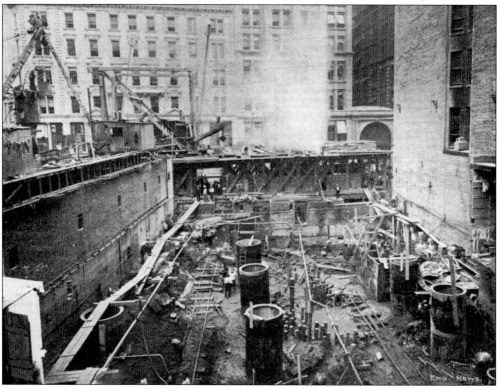

The caissons of the
foundation weighed 15
tons each. They were
lifted and set into place by
heavy-duty boom derricks
and then sunk into the
ground by compressed air.
This view shows a caisson
three sections high in the
process of being sunk.

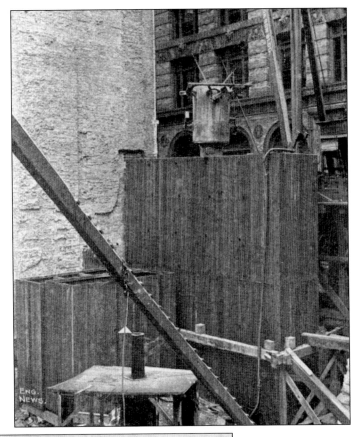

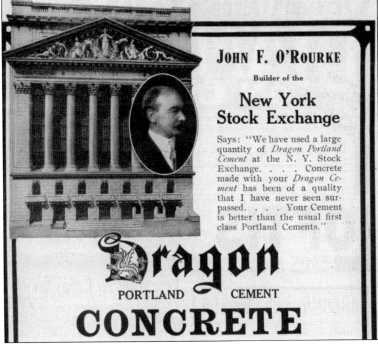

JOHN F. O'ROURKE

Builder of the

New York
Stock Exchange

Says: "We have used a large
quantity of *Dragon Portland
Cement* at the N. Y. Stock
Exchange. . . . Concrete
made with your *Dragon Ce-
ment* has been of a quality
that I have never seen sur-
passed. . . . Your Cement
is better than the usual first
class Portland Cements."

Dragon
PORTLAND CEMENT
CONCRETE

Given the
importance of
concrete in building
the New York
Stock Exchange, an
endorsement from
John O'Rourke
was important
to the maker of
Dragon Concrete.

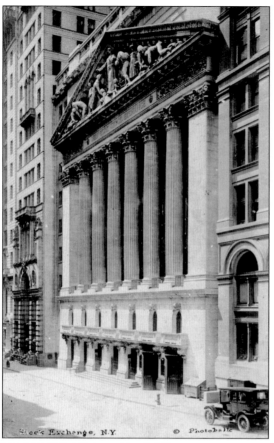

The new building opened in 1903. The statuary on the pediment was the work of John Quincy Adams Ward, who also created the statue of George Washington in front of the Sub-Treasury. To the left of the New York Stock Exchange is the Commercial Cable Building, and at right is the Wilks Building.

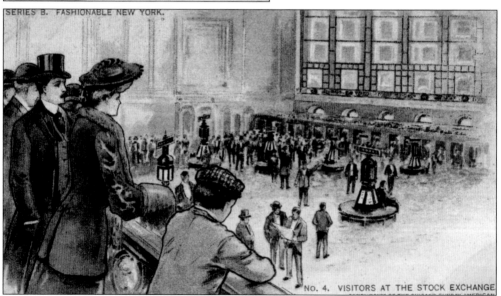

A postcard in the "Fashionable New York" series issued by the Hearst newspapers shows a well-to-do family in the visitors' gallery. Apparently, it was a slow day in the stock market, as one of the floor brokers is reading a newspaper.

The real-photo postcard below shows the second J.P. Morgan & Co. Building at 23 Wall Street at left. It was designed by Trowbridge & Livingston, as was the 23-story addition to the New York Stock Exchange across the street, which was featured in the NYSE's logo at right. The interior of the new Morgan building retained four marble columns from its predecessor, but there was no name above the door. It did not need one. In the 1960s, the building at 15 Broad Street was combined with 23 Wall Street, but in 1989, the bank left for a new structure at 60 Wall Street. In 2004, the site so long synonymous with J.P. Morgan became a condominium project called Downtown by Philippe Starck, named for the French architect who designed the conversion.

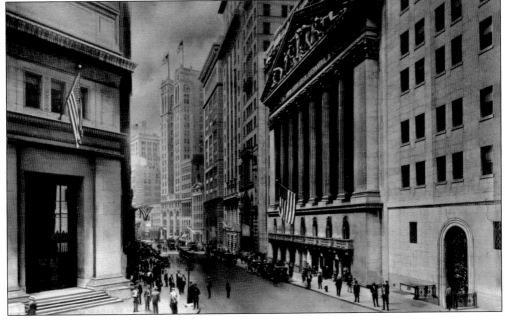

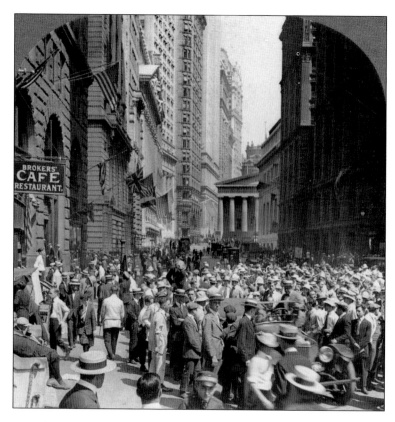

This photograph shows how crowded Broad Street could become with Curb Market traders. A motorist, however, is evidently of the belief that the street might have other uses besides security trading. The New York Curb Market Agency was formed in 1908 to provide structure for the transactions, and a constitution was drawn up in 1911.

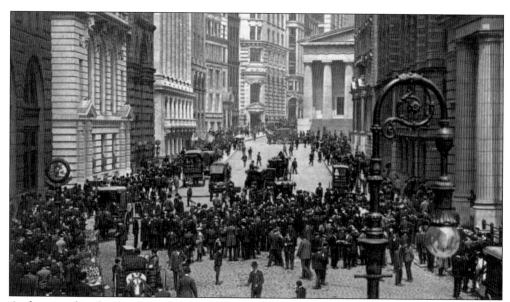

A photographer for the Detroit Publishing Company included a shepherd's crook lamppost in the foreground of this view of the Curb Market traders on Broad Street.

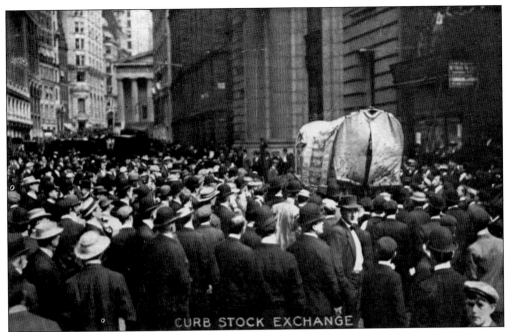

In 1907, Ezra Meeker brought his covered wagon to Broad Street. This postcard states, "Business was suspended, a speech called for and loudly acclaimed by the brokers and multitude." He discovered, however, this was "one of those places much harder to get out of than to get into, but by the help of two policemen a way was opened." For more on Meeker, see page 15.

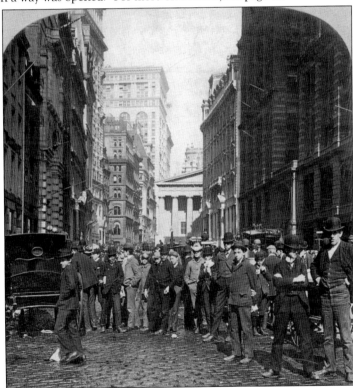

This 1901 photograph of a group of young men standing in Broad Street shows a range of reactions to the presence of a photographer, from curiosity to striking a tough-guy pose.

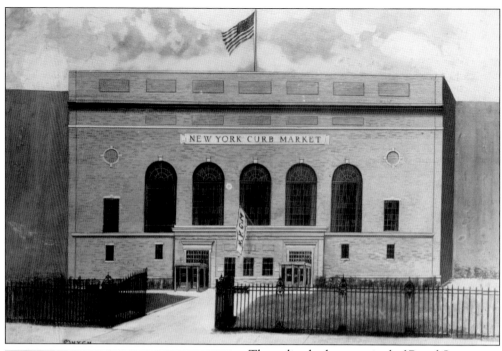

The police had grown tired of Broad Street being perpetually blocked by Curb Market brokers, so the New York Curb Market moved indoors in 1921 to this building designed by Starrett & Van Vleck. The site included a lawn that faced Trinity Place. Urban realities were not entirely left behind, since the building was located between the Sixth Avenue elevated trains on Trinity Place and the Ninth Avenue elevated trains on Greenwich Street.

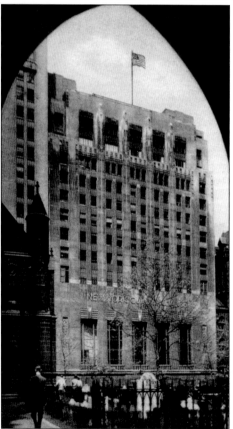

The name was changed in 1929 to the New York Curb Exchange, and two years later, a 14-story expansion was completed. Also designed by Starrett & Van Vleck, it was in an Art Deco style and is seen here through an arch at Trinity Church. In 1953, the New York Curb Exchange was renamed the American Stock Exchange. In 2008, it was acquired by NYSE Euronext, which is now part of Intercontinental Exchange.

Four

FEDERAL HALL AND THE ASSAY OFFICE

This building has had various names—the US Custom House, the Sub-Treasury, and now Federal Hall National Memorial—and has been an important part of the financial district since it was completed in 1842. The initial design was by Town & Davis, but control of the project was taken away from the firm. This stereoview shows the portico facing Wall Street. The Pine Street end of the building has an identical portico.

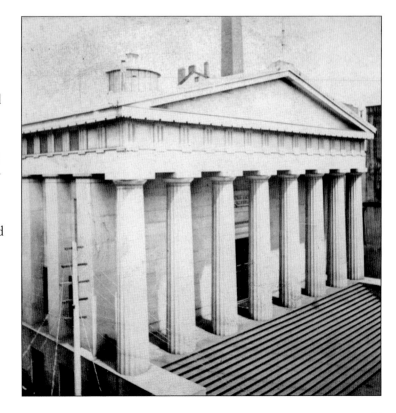

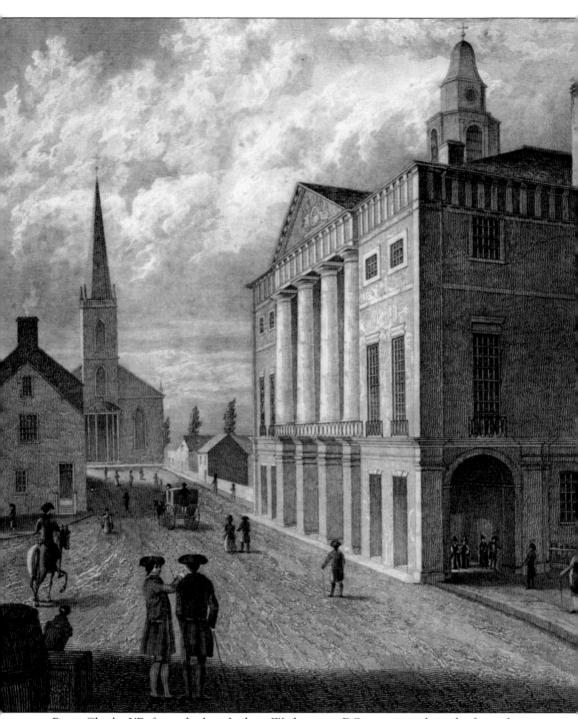

Pierre Charles L'Enfant, who later laid out Washington, DC, was given the task of transforming New York City Hall into Federal Hall, seen here in a steel engraving published in the *New-York Mirror* in 1831. Federal Hall was the seat of the government during the period when New York was the capital of the United States. The chamber of the House of Representatives was octagonal with an arched ceiling 46 feet high at the center and a fireplace beneath every window. The

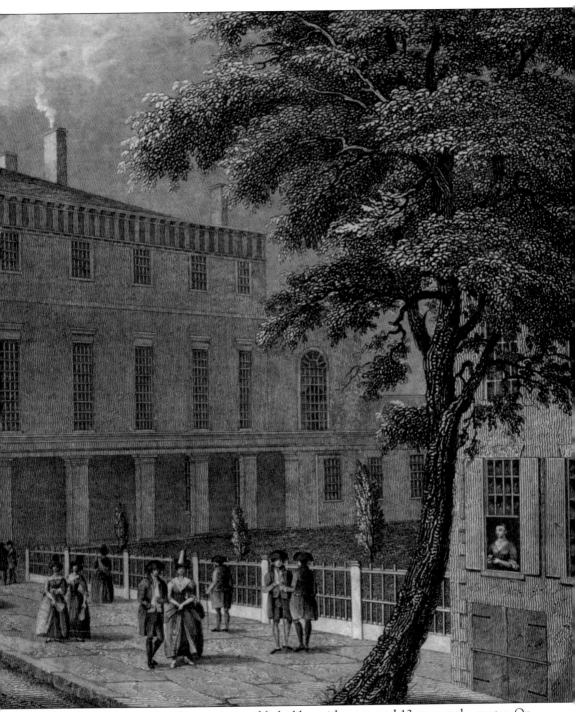

ceiling in the Senate chamber was painted light blue with a sun and 13 stars at the center. On April 30, 1789, George Washington took the oath of office as president from the balcony. The second Trinity Church is in the distance. At right, a woman is standing in a window of the Verplanck mansion, which in the 1820s became the site of the New York Branch of the Second Bank of the United States.

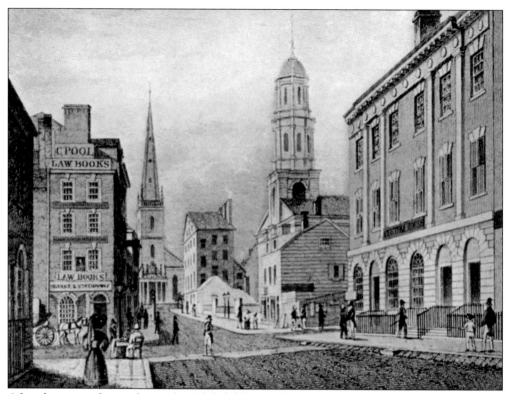

After the national capital moved to Philadelphia, Federal Hall reverted to its role as city hall. It was demolished in 1812, and a new building (at right) was constructed on the site by booksellers Eastburn & Cook. That building was sold to the federal government in 1816 but was torn down in 1834 to make way for the US Custom House designed by Town & Davis. The First Presbyterian Church is on the north side of Wall Street with Trinity Church in the distance.

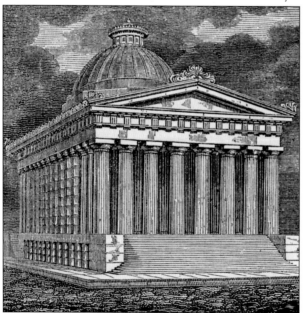

This view of the US Custom House was included in Martha J. Lamb's *Wall Street in History* (1883) with the notation that it was derived "from an original print in 1834." It shows the dome that was designed for the building but was never constructed. The Town & Davis design also called for a double row of columns in the portico at the Wall Street end of the building, but only a single row was actually constructed.

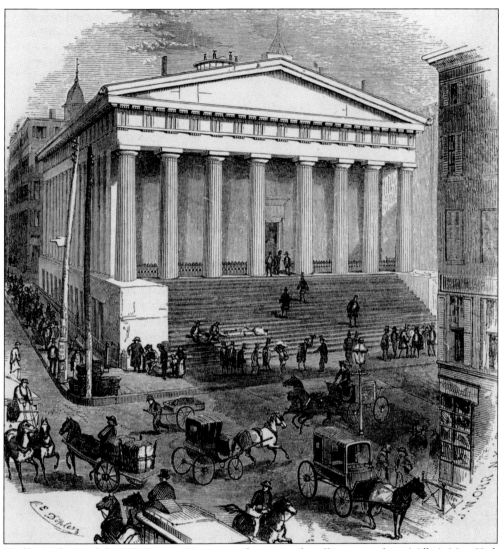

Traffic in front of the US Custom House was heavy in this illustration from *Miller's New York As It Is* (1862). Broad Street is in the foreground with 23 Wall Street to the right. With the fire of 1835 still within memory, a guidebook titled *A Picture of New-York in 1846* assured its readers that "there is not a particle of wood in any part of the building." The book advised the visitor "to enter at the side door in Nassau Street, and from thence ascend to the roof, inspecting the various rooms as he goes up. The key of the roof scuttle may be had by inquiring at any of the offices on the upper floor. There is no objection to the stranger's visiting any part of the building. The roof commands a fine view of the harbor." In 1862, custom operations moved to the second Merchants' Exchange at 55 Wall Street, and this building became the Sub-Treasury.

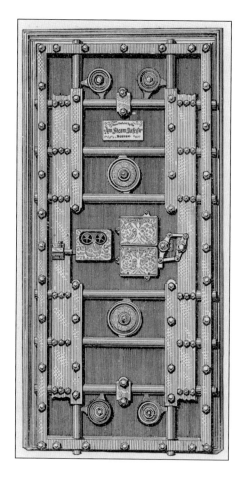

In 1883, Martha J. Lamb noted, "The cash balance in the Sub-Treasury at the present date is about $125,000,000, of which $105,000,000 is in gold and silver coin. This is stored in vaults as inaccessible as the dungeons of the Spanish Inquisition. Numerous great iron doors close over the passages to these vaults, embellished with locks that wind up at night, and which no combination keys can open until they run down again." This view shows the door to the gold vault at the Sub-Treasury.

Lamb wrote, "The gold vaults are built of solid iron, the walls from floor to ceiling covered with tiers of small bins of equal size, in which the coin is packed in bags, and the doors sealed in sealing wax, as shown in the illustration. Each bag contains exactly $5,000. The amount of gold coin in the Sub-Treasury at present is about $72,000,000. In addition to this, there are some $75,000,000 of gold certificates ready for issue."

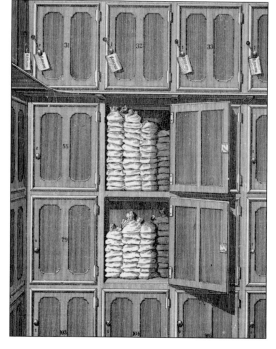

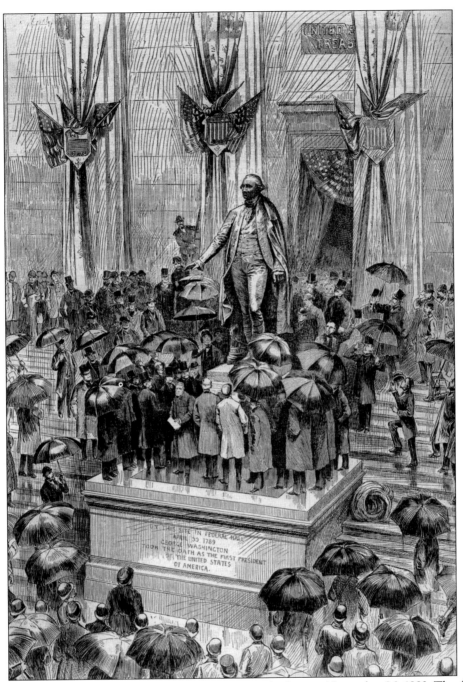

The unveiling of the statue of George Washington took place on November 26, 1883. The date was chosen to reflect the centennial of the evacuation by the British forces at the end of the Revolutionary War, and umbrellas were put to good use on a cold, rainy day. Pres. Chester Alan Arthur, Gov. Grover Cleveland, and the governors of six other states were among the dignitaries in attendance, as were John Quincy Adams Ward, the sculptor, and Richard Morris Hunt, who designed the base. The rain made it difficult to hear the speeches, but the crowd did not seem to mind.

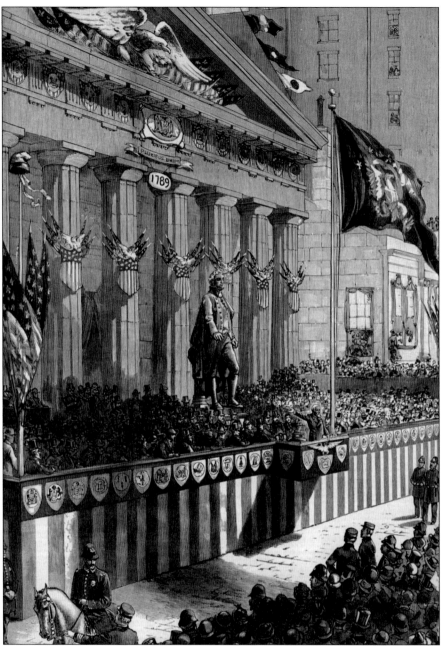

New York devoted three days to celebrating the centennial of Washington's inauguration. On April 30, 1889, Pres. Benjamin Harrison addressed the crowd in front of the Sub-Treasury. Atop the building were maritime signal flags that spelled out "First in war, first in peace, first in the hearts of his countrymen." A portion of the flags can be seen in this illustration from *Harper's Weekly.* The Sub-Treasury was heavily decorated with eagles and flags. A liberty cap, emblematic of the Revolutionary War, can be seen on a pole above the grouping of flags at the left. The shields of the 42 states adorned the platform. The section where the president is shown speaking had the shield of New York at the center, flanked by those of Virginia and Indiana, the latter being the president's home state.

Messenger boys played an important role in communications in the financial district. This ticket, still intact, is for the messengers department of the New York Stock Exchange.

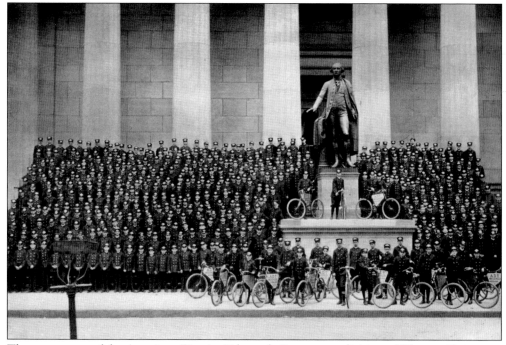

The messengers of the American District Telegraph Company, a division of Western Union, are shown in a gathering on the steps of the Sub-Treasury. Their bicycles carry the company name.

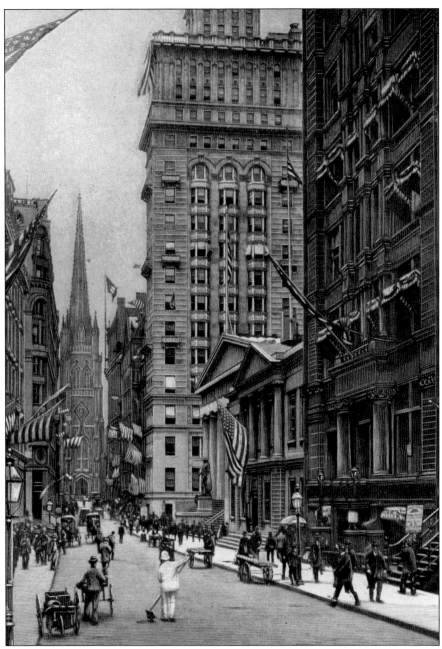

Relying on horse-drawn transportation resulted in an inevitable by-product. To deal with the problem, the city's street cleaning department was organized with crisp efficiency by Col. George E. Waring Jr., who had gained his rank during the Civil War. Workers were known as White Wings, and to encourage esprit de corps, Colonel Waring had them march in an annual parade on Fifth Avenue. In this view from 1899, a White Wing is at work in the middle of Wall Street, which is decorated for a patriotic occasion. He is wearing the requisite white uniform and is wielding the basic tool of his trade—a broom. His wheeled refuse receptacle is nearby. While the White Wings are no longer a part of city life, a cynic might argue that cleaning up the by-product on Wall Street is a task that never quite ends.

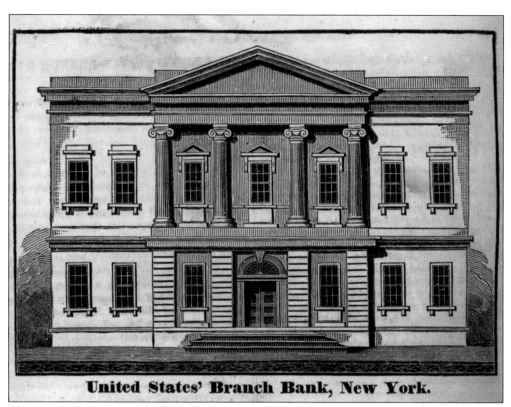

United States' Branch Bank, New York.

The New York Branch of the Second Bank of the United States is seen here in the January 1831 issue of a Philadelphia magazine titled *Atkinson's Casket: Gems of Literature, Wit and Sentiment*. The building was designed by Martin E. Thompson and was completed in 1825. It became the US Assay Office in 1854.

This stereoview looking east on Wall Street was issued by E. & H.T. Anthony & Co. It shows the US Assay Office (at left) and the US Custom House at 55 Wall Street (at right), which has a flag fluttering in the breeze. The masts and yards of a square-rigged ship can be seen in the distance.

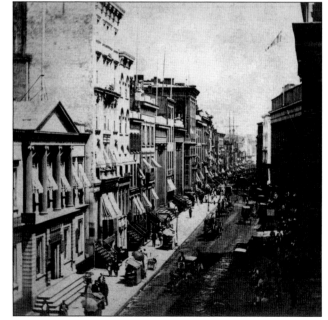

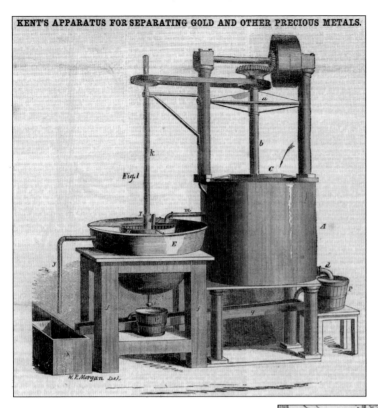

Scientific American visited the Assay Office in 1855 and noted, "The operations of refining the golden products of California are conducted on an extensive scale." Edward N. Kent devised this apparatus to separate gold from "earthy matters." Because the refining process used nitric acid, "a dense, noxious yellow vapor arises from the action of the acid on the metal, and is carried off into the atmosphere through a very high chimney."

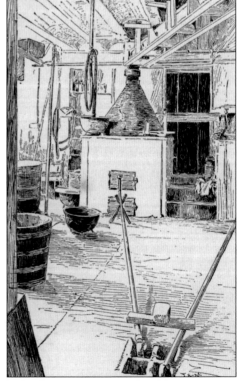

This is an 1883 view of the Boiling Room at the US Assay Office. Martha Lamb commented the following: "In the cool, spacious, elegantly appointed moneyed institutions of Wall Street, it is difficult to realize that fiery furnaces are in constant use under a near neighbor's roof, and that huge kettles of liquid gold and silver, enough to pave the whole street, are stewing and steaming from morning until night."

Robert W. Gibson won a design competition for the New York Clearing House building that was at 77 Cedar Street between Broadway and Nassau Street. It was completed in 1896. The information on this postcard indicates that in 1913 the New York Clearing House had 48 banks and 15 trust companies as members and processed daily average transactions of $323,833,400.

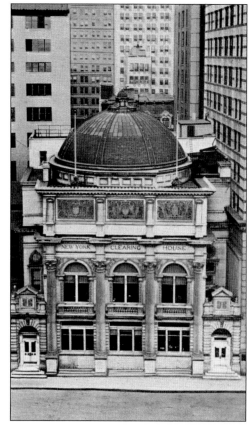

The US Assay Office came down in 1915, but the building was not entirely finished. The stones of the facade were removed and stored until space at the Metropolitan Museum of Art became available. This photograph shows the facade of the US Assay Office when it was newly installed at the American Wing of the Met in September 1924.

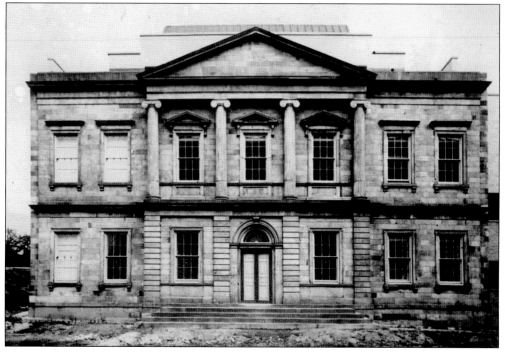

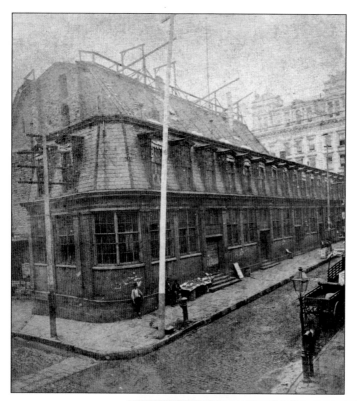

The Middle Dutch Church dated from the 1720s, but in 1844, with the neighborhood having become less residential, it was leased to the government for use as a post office. This stereoview shows the northern end of the post office at the corner of Cedar and Nassau Streets. The steeple has been removed.

I.N. Phelps Stokes dated this photograph at 1866 or 1867. Signs on the stairway mark the Morris Fire & Inland Insurance Co. at 1 Nassau Street (at left). Fisk & Hatch, which was started in 1862 by Harvey Fisk and Alfred S. Hatch, is at 5 Nassau Street (middle background, left of center). The Sub-Treasury is at the right, and the post office, with its steeple intact, is in the background.

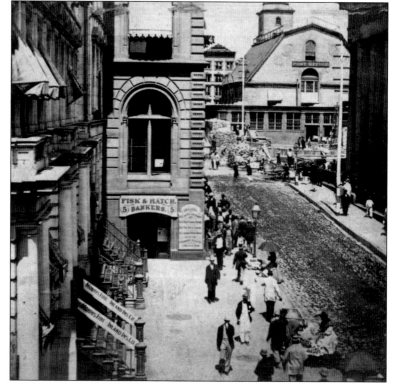

The Gillender Building (at left) was completed in 1897 on a narrow site that had a frontage of only 26 feet on Wall Street. The Hanover National Bank and the first Equitable Building are to the right of the Gillender Building, and the American Surety Building at 100 Broadway and the Trinity Building are to the left. The Gillender Building was demolished in 1910 to make way for the Bankers Trust Building.

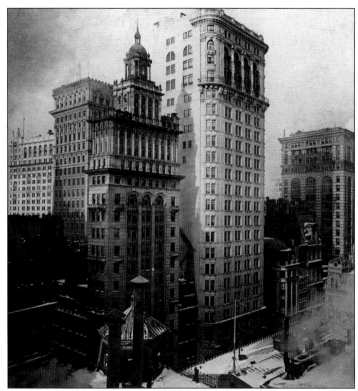

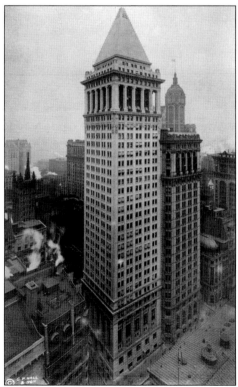

Trowbridge & Livingston was not the first architectural firm to use St. Mark's Campanile in Venice as a model for a skyscraper—Pierre LeBrun had done that with the Metropolitan Life Tower on Madison Square—but the design of the Bankers Trust Building also included a pyramidal roof based on the Mausoleum at Halicarnassus. The building was completed in 1912, and the roof became a corporate symbol for Bankers Trust. The demolition of the Gillender Building and the construction of this structure are documented in the Bankers Trust Virtual Archive on the Skyscraper Museum website.

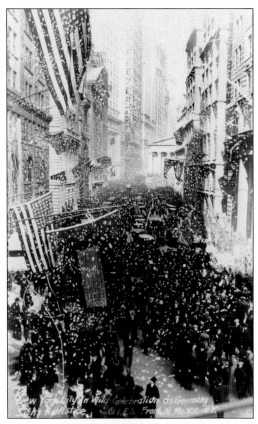

At the Metropolitan Opera, Enrico Caruso marked the end of World War I by singing "The Star-Spangled Banner" between acts of *Samson and Delilah*, followed by the national anthems of the Allies. But the financial district celebrated the Armistice in its usual way—with ticker tape, and lots of it.

This view of the Armistice celebration shows the foundation of the new US Assay Office at 30 Wall Street. The underground vaults in the building were excavated five stories deep to bedrock. The US Assay Office was torn down after Seaman's Bank for Savings bought the building in 1953 and constructed its main office on the site.

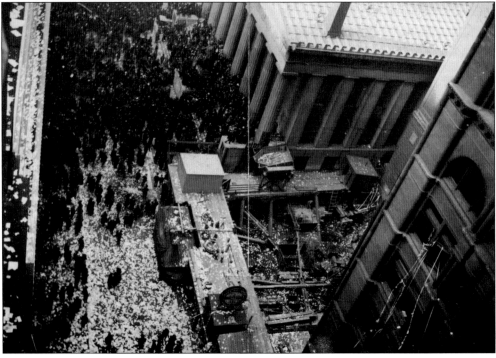

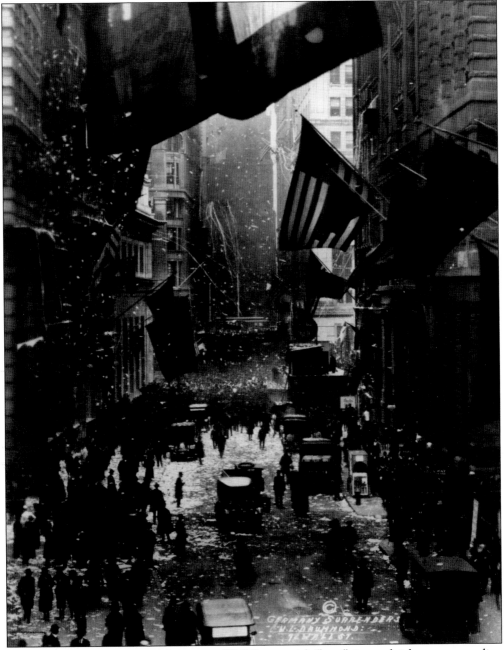

This view of the Armistice celebration on Wall Street, with flags flying and ticker tape cascading onto the street, is looking west toward Trinity Church.

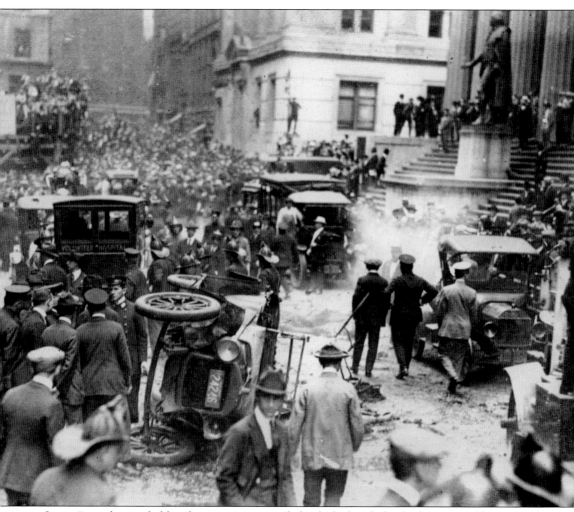

It was "a crash out of a blue sky—an unexpected, death-dealing bolt which in a twinkling turned into shambles the busiest corner of America's financial center." The first-person account of an Associated Press reporter who experienced the September 16, 1920, bombing of Wall Street was printed on the front page of the *New York Times* the following day. "I was just turning into Wall Street from Broadway, when I first felt, rather than heard the explosion." The reporter described the effect as "a concussion of air" and wrote that "instantly following the concussion came a sharp, resounding crash, which shook to their foundations the monster buildings facing either side of Wall Street. With the roar of the blast, came the rattle of falling glass, and from the junction of Wall, Nassau and Broad Streets—a block distant—screams of injured men and women." After placing a phone call to his office, he observed "a mushroom shaped cloud of yellowish, green smoke which mounted to the height of more than 100 feet, the smoke being licked by darting tongues of flame." This newspaper photograph shows some of the havoc that was caused by the blast.

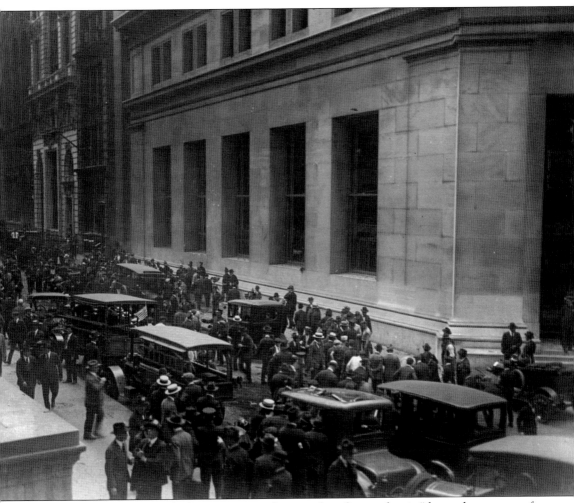

The caption included with this newspaper photograph indicates that it "shows the streams of vehicles on Wall Street, with the Morgan Building on the right, which were used to carry the injured to hospitals and safety." The source of the blast was a horse-drawn wagon loaded with dynamite and window sash weights. It occurred a minute after noon, when the streets were filled with lunch hour crowds. The death toll was 38, with 143 wounded. An exhaustive investigation was unsuccessful at locating the perpetrators. Throughout the 1930s, young detectives in the New York Police Department (NYPD) were given the case to investigate, but they always came back with a lack of results. The damage to the J.P. Morgan & Co. building was never repaired. In his book *Once in Golconda*, John Brooks reported that a Morgan partner cited the cost of replacing the blocks of stone, but then added, "And besides—it's right and proper that they should stay there."

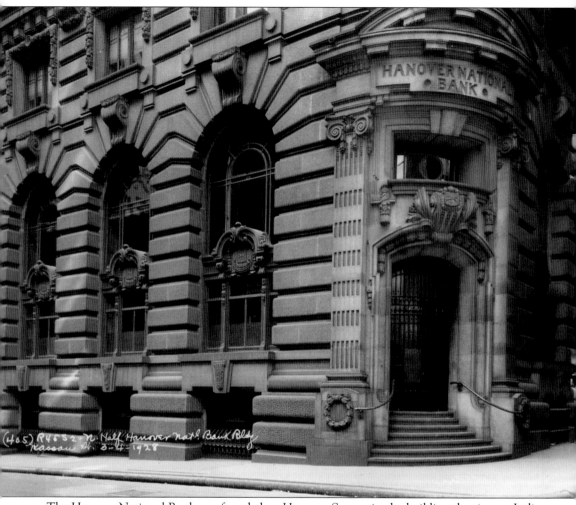

The Hanover National Bank was founded on Hanover Square in the building that is now India House. The bank moved to the southwest corner of Nassau and Pine Streets in 1877 where it constructed a six-story building, which was replaced by this structure in the early 20th century. The date of this photograph, part of a building survey, is March 4, 1928. The typed notation on the back of the photograph offers the following specific details: "Camera in center of Pine St. at E bldg. line of Nassau St. looking SW at northerly half of Hanover Nat. Bank Bldg." The Hanover National Bank Building was torn down in 1931 for an expansion of Bankers Trust. The Bankers Trust Virtual Archive on the Skyscraper Museum website documents the demolition. India House continues to provide a graceful presence on Hanover Square, which became a quieter neighborhood after the elevated trains stopped running in 1950.

Five

THE REALM OF OCEANUS

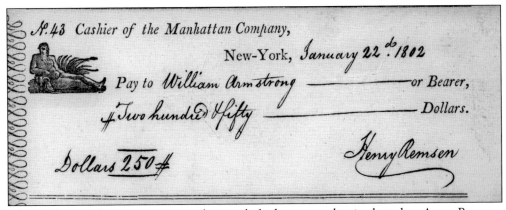

The Manhattan Company was created to supply fresh water to the city, but when Aaron Burr was shepherding the charter through the assembly, he inserted a clause allowing it to go into banking as well. That created a competitor for the Bank of New York, which was closely associated with Alexander Hamilton. The Manhattan Company chose Oceanus, a figure from Greek mythology, for its corporate logo. This check is signed by Henry Remsen, the company's second president.

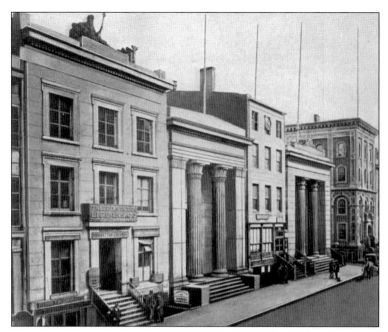

A statue of Oceanus was installed on the roof of the Bank of the Manhattan Company Building at 40 Wall Street (at left) when it was completed in 1848. Later, when the building was expanded by an extra floor, Oceanus was given a new perch on a ledge above the front door. Another statue of Oceanus was placed on the Manhattan Company's reservoir on Chambers Street.

The Merchants' Bank had been headquartered in a converted residence at 42 Wall Street since 1803, and by the late 1830s, it was time to make a change. Isaiah Rogers was hired as architect and designed a Greek Revival building faced in Quincy granite, the same type of stone he chose for the second Merchants' Exchange at 55 Wall Street. The building was completed in 1840.

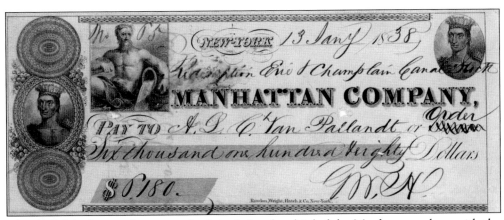

CASHIER of the Manhattan Company,

New-York, 3. *August* 1814

Pay to Mr. *William Gibbons* ~~order~~ or ~~Bearer,~~

one hundred and Twenty five Dollars.

Dolls. *125 —*

Th Gibbons

Thomas Gibbons wrote this Manhattan Company check to his son William in 1814. In November 1817, Gibbons needed a captain for his steam-powered ferryboat, which was nicknamed "the Mouse" because of its diminutive size. He hired a skipper of sailing vessels and budding entrepreneur named Cornelius Vanderbilt, the patriarch of the famous Vanderbilt family. Taking this job provided Vanderbilt access to the new technology of steam power. Gibbons, however, was operating in violation of a monopoly that had been granted by the New York Legislature to steamboat pioneer Robert Fulton and his influential father-in-law Robert R. Livingston. Gibbons's neighbor Aaron Ogden came to terms with the Livingston family and obtained a license that allowed his steamboat to operate between New Jersey and New York. Gibbons, feisty and implacable, challenged the monopoly and brought a lawsuit against Ogden that eventually went to the US Supreme Court, where it was decided in Gibbons's favor in a landmark ruling written by Chief Justice John Marshall. Vanderbilt's career flourished working for Gibbons. He served as captain of the *Bellona*, a larger and more impressive steamboat, and went on to manage the business. After the death of Thomas Gibbons, his son decided to disband operations in 1829, and from that point on, the fiercely independent Vanderbilt would never again work for anyone else. From steamboats he moved into oceangoing steamships and then became a powerful force in the world of American railroads.

This 1838 Manhattan Company check includes the chief of the Manhattans along with the figure of Oceanus. The dollar sign has replaced the abbreviation "Dolls.," which was used on the 1814 check.

BANKS.	OFFERED.	ASKED.	BANKS.	OFFERED.	ASKED.
United States	117½	¾	Illinois State Bank		97
N. O. Canal & B'g Co	96	97	Del. & Hudson Canal Co	90¾	½
" " Mech's & Traders'		98	Morris Canal Co		
" " Commercial	—	104	American Life and Trust Co	99	100
" " City	100	101¼	Ohio do. do.	10¼	10½
" " Gas	96½	¾	Southern do. do.	93	95
Planters' of Tennessee					
Do. of Mississippi	115		RAIL ROADS.		
Vicksburg of do	90	91½	Boston & Providence		
Grand Gulf of do			Boston & Worcester	91	92½
Franklin of Cincinnati	98	103	Exchange on London		
Lafayette of do			" on Paris		
Bank of Kentucky	89	89¼	" on Amsterdam		

SALES.

U S Banks
242 — 117½
50 — 119½ 60ds
50 — 120 63 60ds

Delaware
100 — 92 B30ds
50 — 90
200 — 95 60ds
250 — 90½ S'30ds
100 — 90 8 c@3d
50 — 90½ Cash
50 — 91 tw

Morris Canal
50 — 96
100 — 96
50 — 97½
50 — 96
100 — 96 B10ds

Amer Trust
15 — 99¼
150 — 103 B60ds

Kentucky
50 — 89 @ash

Ohio Trust
100 — 10¼ Cash
60 — 10

Boston &P
100 — 103½ Cash
300 — 107 60ds
150 — 103¾ tw
100 — " Cash
50 — 107¼ B60ds
50 — 103¾ Run

Worcester
100 — 96 60ds
50 — 92½

This market report, dated July 21, 1837, was sent to a client in Philadelphia from Christmas, Livingston, Prime & Coster at 42 Wall Street. The client had submitted a limit order that set a specific price for a transaction. On the second page, the firm noted the price of Morris Canal stock and added, "Which precludes all possibility of our doing anything under your orders."

Sales of Stocks and Bonds at the N. Y. Stock Exchange.

REPORTED BY

DREXEL, WINTHROP & CO.,

No. 40 WALL STREET, NEW YORK.

NEW YORK STOCK EXCHANGE SALES

FIRST BOARD—JAN. 5, 1864.

U. S. 6's 1881 Registered			Copake Iron Mines			Illinois Central R. R. Scrip	
10000		101¼	700		93	600	118
U. S. 6's 1881 Coupon			Wyoming Valley Coal Co			200	s30 118
2000	clean	105¼	50		87	200	s10 118
U. S. 6's 5-20's Coupon			Quicksilver Mining Co			100	s60 118
200		101¼	100	b30	61	400	118¼
2000		101¼	200	b30	60¼	500	118¼
U. S. 5's 1874 Coupon			100		60	500	b15 118¼
1000	Endorsed	97	100		59¾	200	b10 118½
U. S. 6's 1 year certificates			200		59½	100	b30 118½
12000	New	98	200		59½	Cleveland & Pittsburgh R. R.	
Brooklyn City 6's Water Loan			New York Central Railroad			2000	s10 108
2000		106	450		132½	200	103½
Missouri State 6's			200		132½	1000	108
4000		66¼	100	s5	132¼	200	b10 108¼
N Y Central 7's			100	b30	132¾	Galena and Chicago Railroad	
20000		100½	350	b60	132¼	1200	106
Buffalo N. Y. & Erie 1st M			50	b10	132¼	200	106¼
5000		103¼	Erie Railway			100	106¾
Erie 1st Mortgage Bds			2650		109	25	b30 107
2000		109	800		109¼	Cleveland & Toledo R. R.	
Chic & N. Western 1st M			400	b10	109¼	540	122
7000		93	100	s30	109	200	122¼
Chic & N. Western 2d Mtge			100	b30	109¼	250	122¼
3000		74	500	b3	109¼	400	122¼
Toledo and Wabash 2d M			Erie Railway Preferred			800	124
4000		87		b15	103¼	100	s30 123
Chicago & Alton 1st M			Hudson River Railroad			500	b10 124
2000		102	1500	b¼	135	Chicago & N. I. Railroad	
American Exchange Bank			200		134¼	100	s30 127
20		106	300	b10	135	17	128
American Gold			50	s30	134¼	500	128
15000		151¾	Harlem Railroad			100	s30 128
Canton Company			100		91¼	50	s90 128
350		34¼	500		92	100	128¼
200	b10	34¼	200	b10	92	500	129
50	s30	34¼	100	c	91¼	200	b10 129¼
400		34¼	Harlem R. R. Preferred			300	b30 129¼
250		34¼	1100		112	Toledo & Wabash Railroad	
Del. & Hud. Canal Co			Reading Railroad			2500	56
50		178	600	b5	113	1000	b30 56
Cumberland Coal Pref'd			1500	opg	113	200	55¼
1650		50¼	70		112½	Toledo & Wabash Pref'd	
500		50¼	500	b15	113	100	70
50	s30	50¼	500	b30	113¼	Pitts Ft Wayne & Chicago	
100	s60	50¼	100	c	112½	1000	86
50	b10	50¼	Michigan Central Railroad			300	86¼
800		50¼	100		120¼	1200	86¼
100	s30	50¼	Mich. So. & N. I. Railroad			100	86¼
200	s10	50¼	100		86	300	b5 86¼
550	b10	51	200		86¼	150	b30 87
100	b15	51	200	b10	86¼	200	b30 86½
400		50¼	1000		84½	100	s30 86¼
300	b3	51	300		86¼	400	s30 86¼
300	b30	51¼	100	b10	87	200	b10 86¼
Mariposa Mining Co			1200		87	200	b10 86½
300		34¼	300	b10	87¼	100	b5 86¼
200	b30	34¼	Panama Railroad			Chicago & N. Western R.	
200	b30	35¼	14		201	400	47
200	s30	34¼	Mil. & P. Du Chien R. R.			Chicago & Alton Railroad	
300		34¼	100		57	500	85
100	b15	34¼	150		57¼	Miss & Missouri R	
2300	s30	34				200	33

A market report issued by Drexel, Winthrop & Co. of 40 Wall Street on January 5, 1864, gives every indication of having been printed in haste. It supplies the results of that day's first trading session, which was known at the time as the first board. The other side of this document reports on the second session. Drexel, Winthrop & Co. was a partnership between the Drexels of Philadelphia and Robert Winthrop. Winthrop created his own firm, Robert Winthrop & Company, in 1871.

81

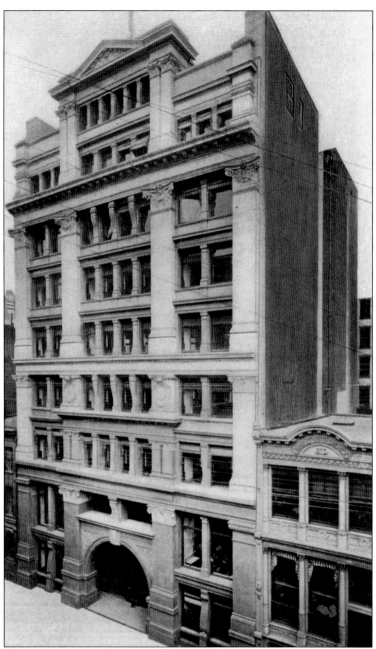

The building boom of the 1880s came to 40 and 42 Wall Street when the Bank of the Manhattan Company and the Merchants' Bank built this ponderous Victorian structure on the site where their two separate buildings had previously been located. Designed by W. Wheeler Smith, the new building opened in July 1884. It was 70 feet wide and extended through to Pine Street. A contemporary description noted that the front of the building had "granite of different tints, much of it polished, and with an unusual amount of rich carving." The Pine Street exterior was much less impressive, with brick and granite "very plainly treated." Despite sharing the building, the Bank of the Manhattan Company and the Merchants' Bank continued to function independently. A marble partition within the building separated their operations.

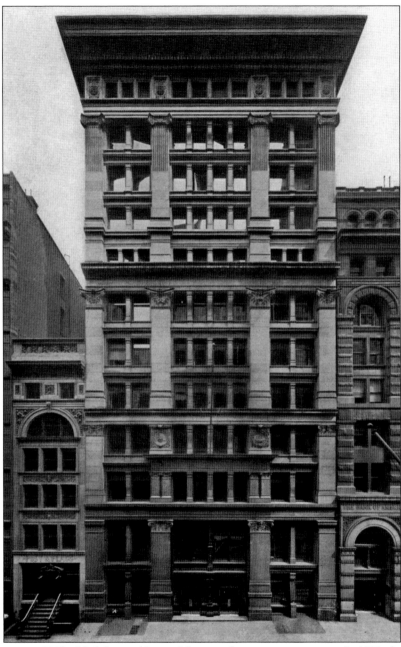

An expansion in 1903 added three additional floors and an imposing cornice. In 1920, the partition that had previously separated the Bank of the Manhattan Company and the Merchants' Bank was taken down when the two banks merged. What made that particularly interesting, given Aaron Burr's pivotal role in the creation of the Bank of the Manhattan Company, was an otherwise obscure historical fact: back in 1803 the Articles of Association of the Merchants' Bank had been drawn up by Alexander Hamilton. A history published by the Bank of the Manhattan Company in 1920, *Early New-York & the Bank of the Manhattan Company*, noted that "with the consolidation the partition is torn down, the two interiors thrown into one and remodeled into one of the handsomest bank interiors in America." All of that was gone by the end of the decade.

This is a view of the interior looking toward Wall Street after the 1903 remodeling of the Merchants' Bank. In the foreground is the gate dividing the outer lobby from the banking area.

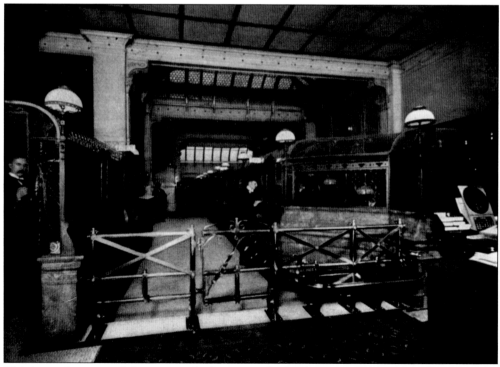

This is another view of the interior, looking into the banking area. Note the grillwork on the tellers' cages.

40 WALL STREET

NEW HOME OF

CHARLES F. NOYES COMPANY, Inc.

MANAGING AND RENTING AGENT
FOR THE BUILDING

The 1920s building boom resulted in a skyscraper at 40 Wall Street, seen here on a trade card issued by the rental agent. The Bank of the Manhattan Company Building was designed by H. Craig Severance and Yasuo Matsui and constructed on a tight schedule. Demolition on the site began in May 1929, and construction was complete by May 1, 1930. But 40 Wall Street, which is now the Trump Building, appears destined to exist in the metaphorical shadow cast by the Chrysler Building. The architect of the Chrysler Building, William Van Alen, was a former partner of Severance. After 40 Wall Street had topped out at 927 feet and appeared ready to claim the title of the world's tallest building, Van Alen unveiled his surprise. A spire had been secretly constructed inside the Chrysler Building, and when it was raised into place, the Chrysler Building was able to claim the height advantage. The title of world's tallest building lasted for less than a year. It was taken away by the Empire State Building, which was completed in 1931.

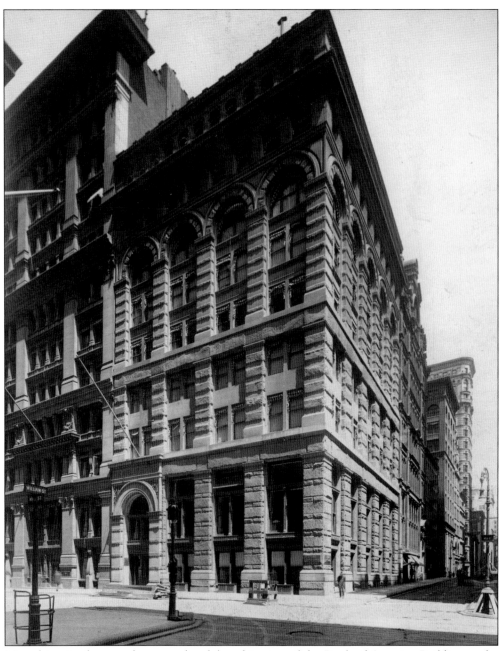

Many historic photographs are undated, but this view of the Bank of America Building at the northwest corner of Wall and William Streets was part of a building survey, and the accompanying documentation indicates that the photograph was taken at 11:00 a.m. on May 9, 1915. The building was designed by Charles W. Clinton and was completed in 1889. Along with the Romanesque arch above the entrance, this building had a "wide entry of white marble, with a broad marble stairway leading to the banking floor," according to *A History of Fifty Feet in New York at Wall & William*, a book published by the bank in 1926. The book also noted that the "two electric passenger elevators were pridefully pointed out by the citizens of New York." Bank of America replaced this building with a Trowbridge & Livingston design that was completed in 1926.

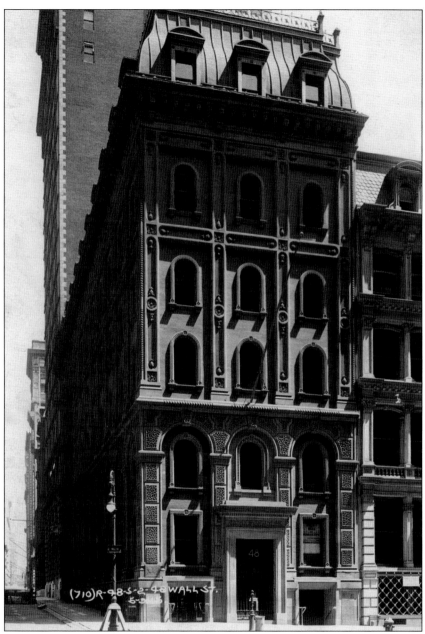

The Bank of New York purchased the property at the northeast corner of Wall and William Streets in March 1796 and moved into its first building there in 1798. That structure was replaced by this building designed by Calvert Vaux, which was constructed between 1856 and 1858. The design employed dark red brick trimmed with brownstone. The stonework around the entryway was vermiculated, a decorative treatment where the stone is carved with wormlike patterns. The building expanded upward when a floor with a mansard roof was added in 1879. This photograph, part of that same building survey, was taken May 9, 1915, at 10:55 a.m. A new building on the site, designed by Benjamin Wistar Morris, was completed in 1927 and now houses the Museum of American Finance. Today, Calvert Vaux is best known for his work with Frederick Law Olmsted in creating Central Park.

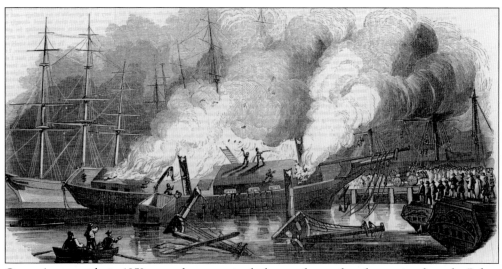

On an August night in 1852, a watchman noticed a large volume of smoke coming from the *Robert Center*, a ship moored at Pier No. 19 at the foot of Wall Street. The fire could not be contained, and the destruction of the *Robert Center* hit close to home in another way. The ship's cargo was valued at $40,000, of which about $16,000 was insured by Wall Street firms.

This stereoview shows three ferries on the East River. The ferry at top left is heading to Wall Street. A schooner can be seen above the ferry at right.

Shipping, not finance, dominates the eastern end of Wall Street in this 1859 woodcut published in the *Illustrated London News*. The Wall Street Ferry can be seen between sailing ships. The paper noted that the ferries were "capable of accommodating a thousand persons, besides a dozen carriages or wagons." With less than impressive powers of prediction, the paper commented, "The East River, between New York and Brooklyn, is too broad and deep for a bridge, though a bridge has often been proposed to connect the two; but as, in addition to engineering difficulties, the bridge would impede the rapidly-increasing commerce of New York, and especially of the whole of one side of the island of Manhattan, the idea seems to have been generally abandoned, as either impracticable or inexpedient." Needless to say, the building of the Brooklyn Bridge decided the matter otherwise. In this view, Brooklyn can be seen in the distance. The paper noted that it "is a quiet and elegant city, offering a very remarkable contrast to its uproarious and prosperous neighbor of New York."

The Wall Street arch was part of the 1889 celebration of the centennial of George Washington's inauguration. Benjamin Harrison is depicted on the left column, and George Washington is on the right column. The allegorical figure of Columbia is at the top.

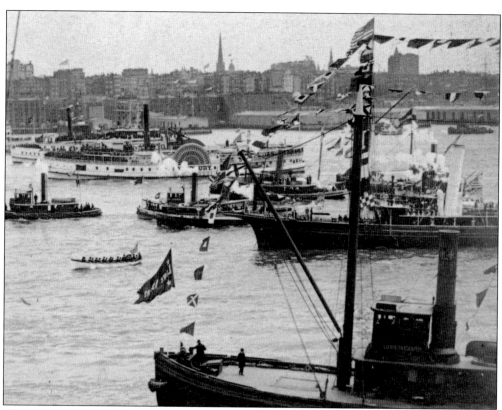

The boat that carried President Harrison to Wall Street was a replica of the one that had brought George Washington to the same site 100 years earlier. The steam-powered maritime entourage that was afloat in 1889, however, consisted of vessels that were much larger than the presidential boat, which can be seen in the middle foreground toward the left in this stereoview.

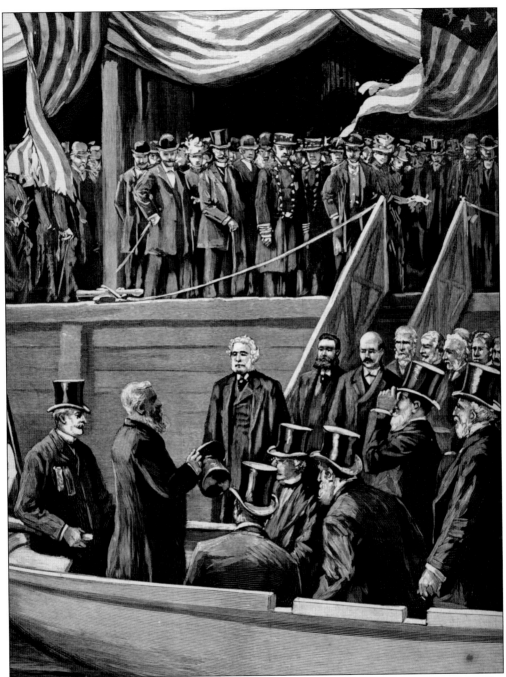

President Harrison's boat is shown landing at the foot of Wall Street on April 29, 1889. The president holds his hat in his right hand. Some of the captains from the Marine Society of the City of New York who had rowed the boat can be seen with the president, wearing silk hats. Their predecessors in the organization had handled the same duties for George Washington. *Harper's Weekly* stated, "Wall Street was magnificently decorated. The principal buildings were almost hidden behind bunting." For President Harrison's speech at the Sub-Treasury the following day, see page 64.

The Wall Street Ferry opened in 1852, but financial difficulties led to its becoming part of the Union Ferry Company, which was the leading company providing ferry service between Lower Manhattan and Brooklyn. The Fulton Street Ferry, which linked Fulton Street in Manhattan with Fulton Street in Brooklyn, was the company's most important route.

The Brooklyn terminus of the Wall Street Ferry at Montague Street is seen here. Manhattan is in the distance.

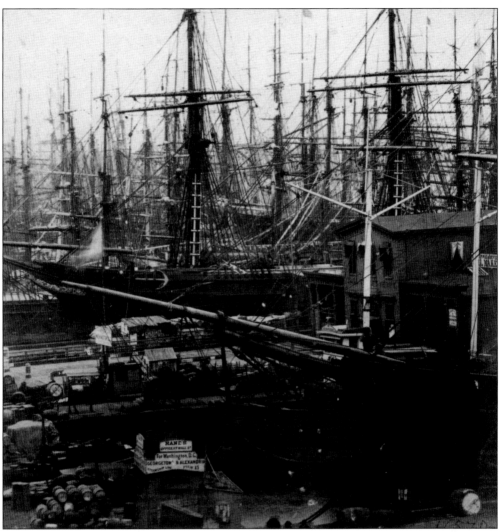

The Wall Street Ferry building appears nearly surrounded by a dense forest of ships' masts in this 1865 stereoview by E. & H.T. Anthony & Co., confirming Walt Whitman's description of Manhattan as "mast-hemmed." In their book *Maritime New York in Nineteenth-Century Photographs*, Harry Johnson and Frederick S. Lightfoot identify the ship in the foreground as the *Dreadnought*, a three-masted medium clipper ship built in 1853 by Currier & Townsend in Newburyport, Massachusetts. The medium clippers were not quite as fast as the extreme clippers but were more practical because they could carry more cargo. On his website chronicling the clipper ships, Lars Bruzelius has noted that the *Dreadnought* left Liverpool bound for San Francisco on April 28, 1869. On July 4, the ship "drifted ashore and was wrecked on Cape Peñas, off Tierra del Fuego." After 17 days in the ship's boats, the crew was rescued by a Norwegian ship.

This cachet was issued on September 5, 1934, to mark the opening of what became known as the Downtown Skyport. It offered the promise of "New York's beautiful seaplane base forming an oasis of suburban charm in the shadows of towering skyscrapers"—if, that is, one's suburb included seaplanes.

The Downtown Skyport is depicted on this postcard. What appears to be a series of diagonal lines on the building to the right of the Skyport is a fire escape. A 1937 film clip shows seaplanes landing in the East River and then coming up the ramp and stopping to allow passengers to disembark.

Six

55 WALL STREET AND SOUTH

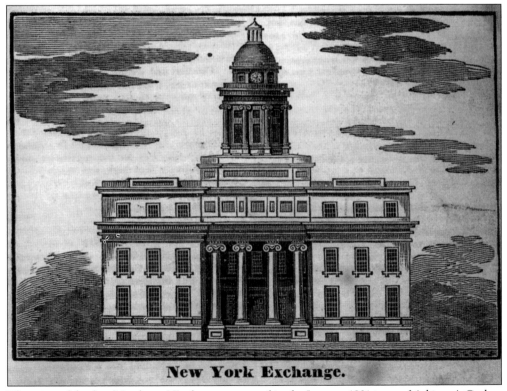

New York Exchange.

This view of the first Merchants' Exchange appeared in the January 1831 issue of *Atkinson's Casket: Gems of Literature, Wit and Sentiment*, which described it as "one of the greatest ornaments of the city." It was designed by Martin E. Thompson and was completed in 1827. Each of the four Ionic columns was 27 feet high and carved from a single block of marble.

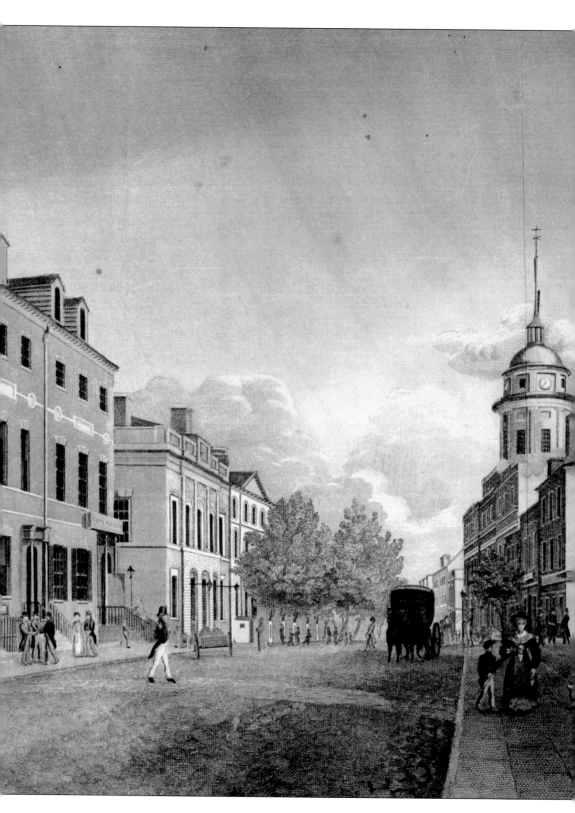

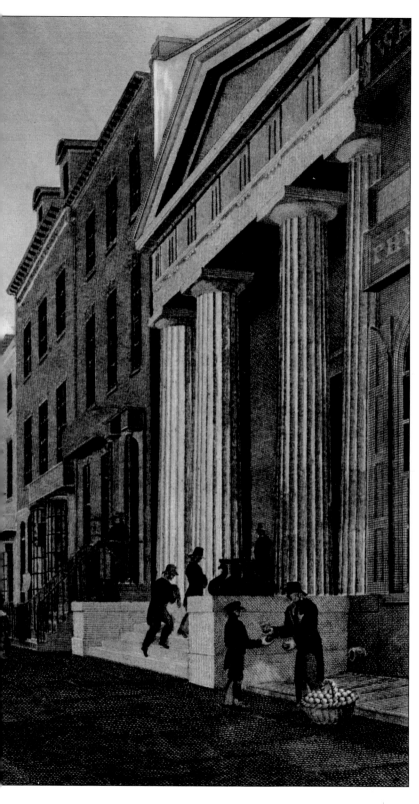

Nothing about this peaceful Wall Street scene hints of the disaster that was to come. This steel engraving was published in the *New-York Mirror* in 1832. A mother and son are walking the family dog in front of the Phenix Bank (at right), and an apple seller is making a sale. The design of the Phenix Bank has been attributed to Martin E. Thompson. Farther down Wall Street is the cupola of the Merchants' Exchange. The intersection at the left side of this view is at William Street. The first Bank of America Building is at the northwest corner of Wall and William Streets, and the Bank of New York is at the northeast corner.

97

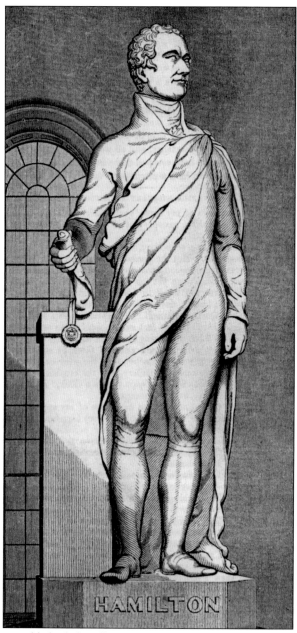

HAMILTON

The *New-York Mirror* published this illustration of Robert Ball Hughes's statue of Alexander Hamilton in its October 24, 1835, issue. The statue, which was 15 feet high, had been installed in the Merchants' Exchange in April of that year. Hughes had studied at the Royal Academy in London and came to New York when he was 23 to embark on a career as a sculptor. His original design for the Hamilton statue, which is preserved in preliminary models of the work, portrayed his subject in contemporary clothing. The finished statue was carved from a block of Carrara marble. When it became evident that the marble contained a flaw, Hughes changed the design to show Hamilton in a toga. Art historian Wayne Craven calls this "the first marble portrait statue executed in America." This illustration in the *New-York Mirror* was the first depiction of the completed work. Unfortunately, it would also be the last.

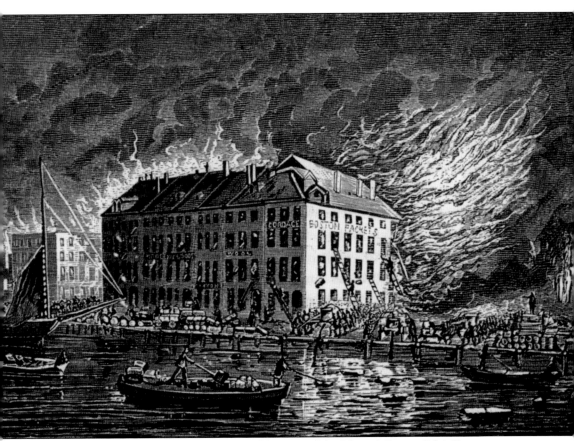

In his book *Our First Century*, a centennial history of the United States, R.M. Devens wrote, "Modern history affords but few instances of more awful desolation by fire, than that which so suddenly visited the city of New York, on the sixteenth and seventeenth of December, 1835. Indeed, there are not many examples of any calamities affecting property and business interests, showing greater destruction or involving consequences more distressing. The consuming of nearly seven hundred spacious storehouses of the first class, filled with the most valuable goods of all kinds and from all countries, covering about twenty acres of land, and giving employment in various connections to several thousand persons, was an unprecedented event, in the roll of national disasters." This is a view of the fire from Coenties Slip. Because the Merchants' Exchange was thought to be a safe haven from the flames, "the building was selected as the grand depot for the most precious kinds of merchandise that could be rescued from the adjacent streets, and with which its great hall was completely piled."

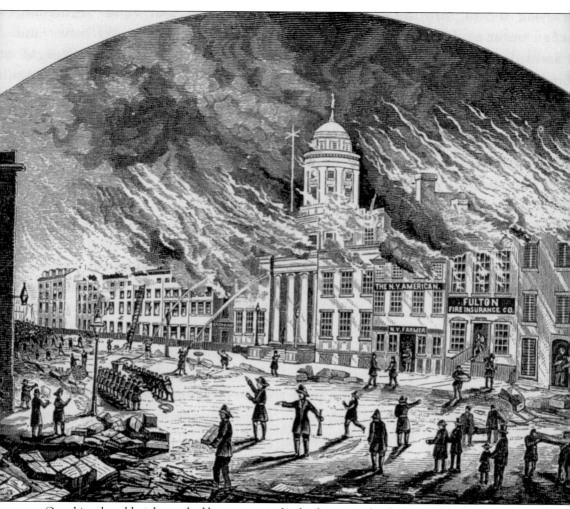

On a bitterly cold night marked by strong winds, the fire seemed to be "some fabulous monster of destruction, waving its wings over its helpless and devoted prey." Hopes of saving the Merchants' Exchange proved illusory. Devens wrote, "At about one o'clock in the morning the splendid edifice took fire, and although the flames preyed upon it but slowly for some time, they at length burst forth from its roof and dome, and weaved a pall of ruin over its vast and beautiful form. For full half an hour, the flames arose in pyramidal columns, from its dome, up to an immense height in the troubled sky, and rendered it a most sublime though fearful object. But before the unhappy persons who had made it a refuge for their property . . . could again rescue scarcely an article, the dome fell in with a portentous crash, burying beneath its ashes the new and beautiful statue of the illustrious Hamilton." Sailors from the Brooklyn Navy Yard had made an attempt to save the statue but were forced to flee.

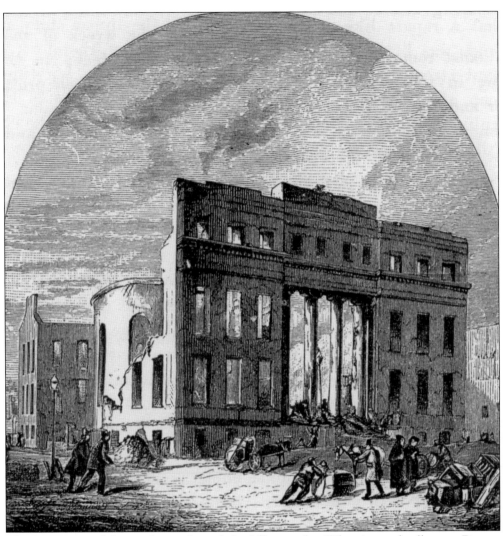

The fire continued for another night and the following day. When it was finally over, Devens noted that "it required but a slight stretch of the imagination, for the beholder to feel as though he were in the vicinity of Pompeii, with Vesuvius sending up its lurid glare close at hand, throwing a melancholy light over the deserted ruins. Just here arose a large and ragged pile, where the corners of four stately buildings still stood up by mutual support; there towered grandly a solitary chimney; yonder stood the frowning fragment of a vast wall . . . But here is the grandest ruin of all—the Exchange! with its huge pillars rent and torn from top to bottom, and the massy architraves, like the antiquated temples of Carthage and Palmyra, still tottering upon their capitals! So vast was the barren waste, that an uninterrupted view was afforded from Wall Street to the East River, and thence to Coenties Slip; a prospect of awful grandeur, as far as the eye could reach."

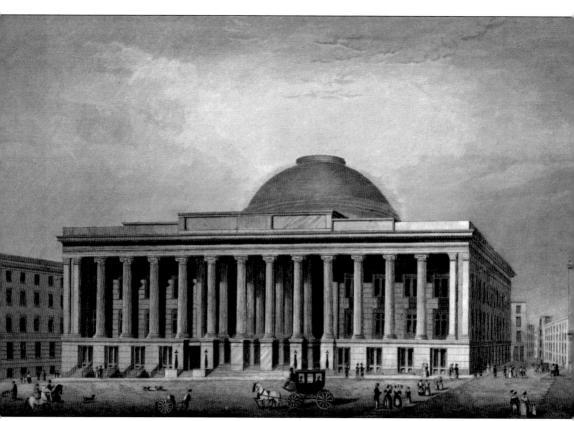

The decision to rebuild was quick, the process of choosing an architect took longer, and the actual construction was longer still. The design submitted by Isaiah Rogers, the architect of the Astor House, was accepted. Rogers used granite from a quarry in Quincy, Massachusetts, and each of the columns was carved from a single block. The dome was 80 feet in diameter and created a rotunda beneath it for the main room in the building. The Merchants' Exchange was completed in 1842, and S. Walker of Boston published this steel engraving the following year. The New York Stock & Exchange Board (as the NYSE was then known) was a tenant. An account from 1848 indicates that during the two trading sessions, from 10:30 a.m. to noon and from 2:45 p.m. to 3:00 p.m., "members are called to order by the President, who commences the business of the Board by repeating the names of the different stocks or securities, pausing at each for the members to buy or sell." The building became the US Custom House in 1862.

The headquarters of National City Bank of New York at 52 Wall Street, which is seen here in an 1890s view, was across the street from the US Custom House. The bank had been at this location since its founding in 1812. National City Bank merged with the First National Bank in 1955 and became Citibank in 1976.

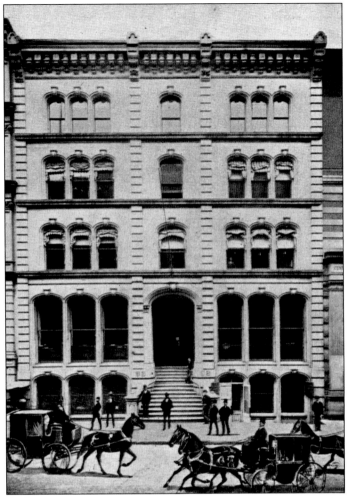

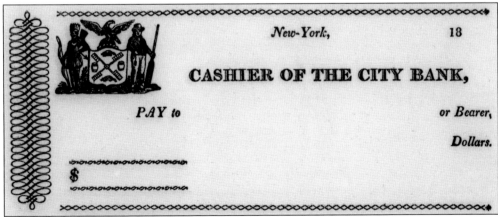

Unlike the Bank of the Manhattan Company, which featured a figure from Greek mythology, City Bank used imagery from the New York City seal on this 19th-century check. A national banking system was created during the Civil War, and in 1865, City Bank became National City Bank of New York.

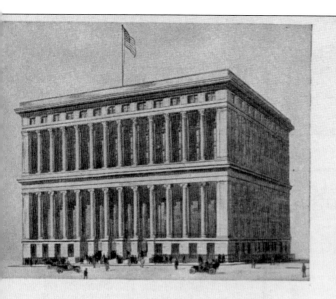
James Stillman, president of the National City Bank from 1891 to 1909, expressed his view of leadership in the following direct terms: "My conception of banking is that a bank's resources should be handled as a general handles his soldiers." When 55 Wall Street came on the market, the bank purchased it in 1899 for $3,265,000 and then waited until the new US Custom House was completed. McKim, Mead & White added four additional stories and a row of Corinthian columns above the Ionic columns of Isaiah Rogers's design. The project was completed in 1910. According to a Citibank history, *55 Wall Street: A Working Landmark*, during the renovation workers came across "a cannonball embedded in a wall, as well as a keg of gunpowder and more than 100 old-fashioned bombs," which dated from the time of the draft riots in 1863. The far more mundane task of supplying the paint for the building was something worth touting in an advertisement.

National City Bank issued a series of postcards showing the austere elegance of their headquarters building unencumbered by the presence of customers or employees. This view shows the main entrance. McKim, Mead & White completely redesigned the interior.

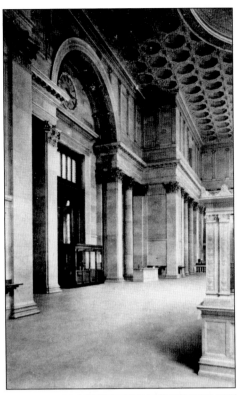

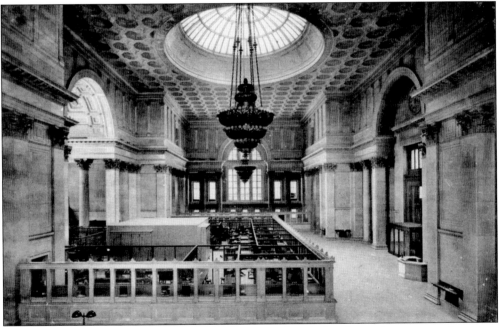

This view looks west in the main banking area and includes the main entrance (at right). *55 Wall Street* stated that "the Great Hall had the feel of a Roman basilica—one buttressed by modern technology." There are actually two bronze chandeliers in this view. One is suspended from the dome, and the other is farther back in the room.

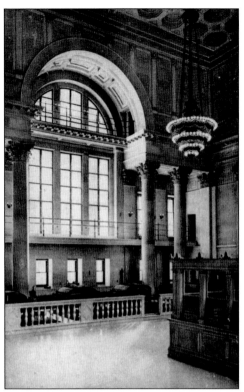

A barrel vault supported by Corinthian columns marked the executive area at 55 Wall Street (at left). An elaborate grouping of windows provided ample light. A portion of the tellers' cages can be seen at right, along with a chandelier.

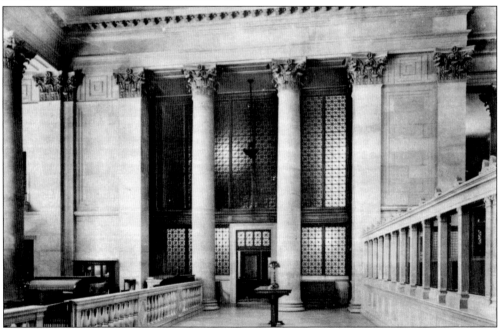

The entrance to the president's office was between two Corinthian columns (at center). Citibank moved its headquarters to midtown in 1961, and the branch here closed in 1992. The building is currently the home of Cipriani Wall Street, a facility that includes a restaurant and an event space, and the Cipriani Club Residences, a condominium project.

It was here at Broad and Pearl Streets in 1762 that Samuel Fraunces opened the Queen's Head Tavern. Its most celebrated event took place on December 4, 1783, when George Washington said farewell to his officers. In the 19th century, the building suffered from fires and various remodeling projects. Two floors were added, and at the turn of the 20th century, a final indignity was signage that had the misspelling "Fraunce's."

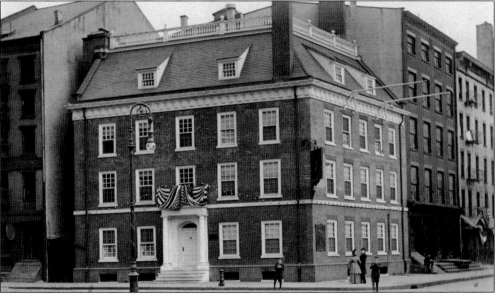

The Sons of the Revolution in the State of New York saved Fraunces Tavern from demolition and brought in architect William H. Mersereau for its renovation. Lacking documentation of the early appearance of the building, Mersereau proceeded on a best-guess basis for the project, which was completed in 1907 and is seen here in a Thaddeus Wilkerson photograph. The building is a city landmark and is part of the Fraunces Tavern Block Historic District, which includes structures from the 1820s and 1830s.

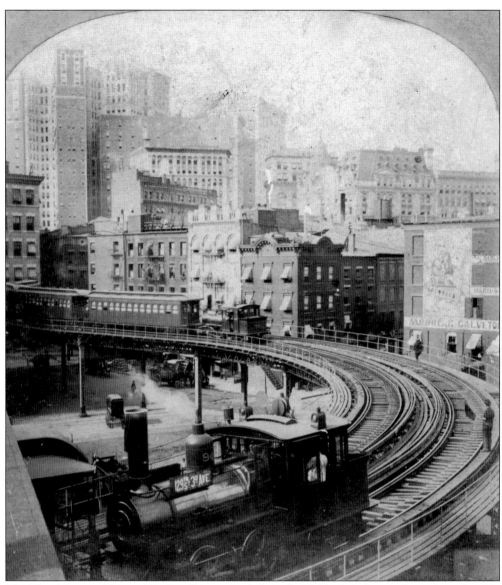

The Third Avenue Elevated Railroad came north from South Ferry and went through an S-curve at Coenties Slip. It then headed into the financial district along Pearl Street. In this stereoview, the photographer has included both northbound and southbound trains on the S-curve, each powered by a transit-size Forney locomotive. A reporter for the *World* who rode the el on its first day of operation noted, "There were two handsome cars on the train of maroon color, touched with gold and light paints, and glistening with varnish." For the reporter, the noise level was significant and stated, "Through Pearl Street it ran, making a deafening clatter with the rattle of the road itself, the grinding of the wheels and the reverberations from the buildings. People in the street below, however, seemed to pay no attention to the engine and cars, and the horses stood quietly in front of their trucks and carts, without drivers near, and munched their fodder."

The Coenties
Slip S-curve
was a favorite of
photographers.
This stereoview
was able to capture
something of a
sinuous grace in its
design. Note the
shipping in the East
River. Brooklyn is
in the distance.

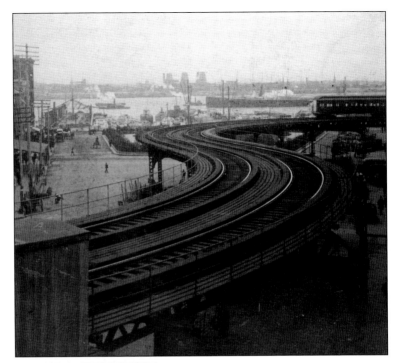

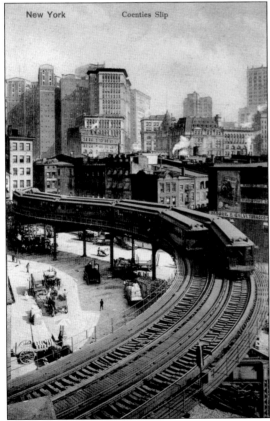

This postcard shows two trains on
the S-curve after electrification in
the early 20th century. The trains
stopped at Hanover Square and
Fulton Street. The final run for the
downtown section of the Third Avenue
el was on December 22, 1950.

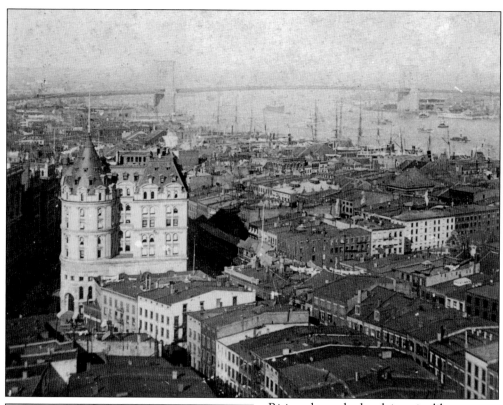

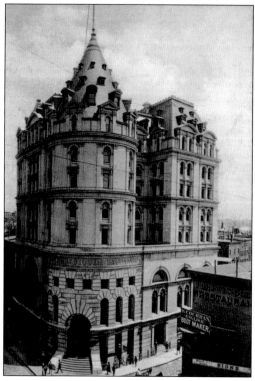

Rising above the low-lying city like a French chateau on the landscape, George B. Post's Cotton Exchange was part of the 1880s building boom in the financial district. The Brooklyn Bridge can be seen in the distance. Post got the job of designing the Cotton Exchange by winning a design competition. The building was completed in 1885. The lower part of the Cotton Exchange was clad in a type of stone called Kentucky oolite. Post used brick and terra-cotta for the upper stories, and the building was topped off by a red slate roof. Post also designed the Produce Exchange on Bowling Green and the 1903 New York Stock Exchange building.

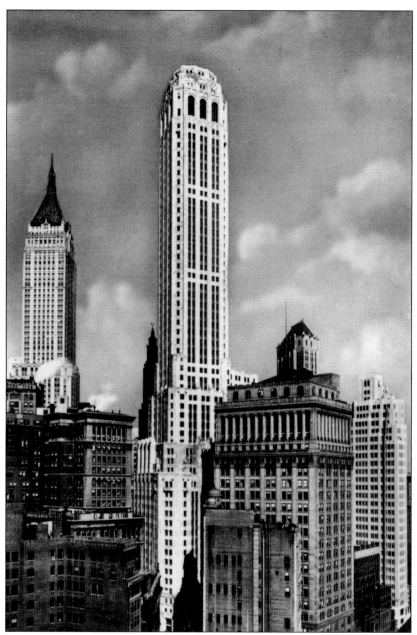

Many of the structures built in the 1880s in the financial district were swept away during the boom times of the 1920s, and Post's Cotton Exchange was no exception. The new Cotton Exchange, completed in 1923, is the building just to the right of center with the colonnade on the upper floors. The City Bank Farmers Trust Building at 20 Exchange Place towers over it. The name reflects a 1929 merger of the Farmers Loan and Trust Company with National City Bank. The building was designed by Cross & Cross and was completed in 1931. An article in *Architectural Forum* indicated, "The architects hold no brief for any particular architectural style." The *New York Times* reported that when it opened "visitors thronged the building all day, an hourly average of 3,851 guests passing into the new quarters through the main entrances during business hours." In this photograph, 40 Wall Street is the tall building with the spire that is seen at the left.

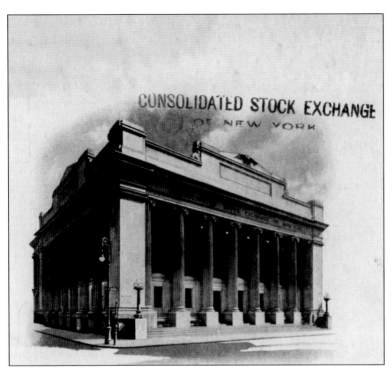

Clinton & Russell designed the Consolidated Stock Exchange Building at the southeast corner of Broad and Beaver Street. It was completed in 1907 and featured a dome with a central skylight. The Consolidated Stock Exchange achieved some success in catering to small investors, but facing the opposition of the New York Stock Exchange and experiencing serious internal problems, it went out of business in 1927.

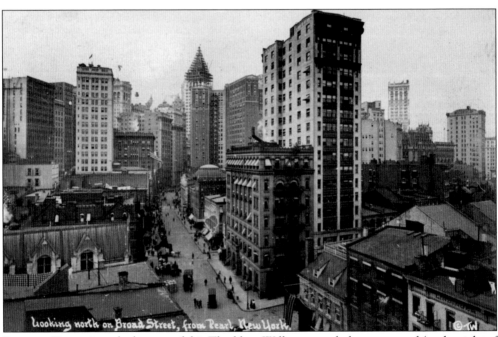

Fraunces Tavern is at the bottom of this Thaddeus Wilkerson real-photo postcard (to the right of the title line). The dome of the Consolidated Stock Exchange (at center) is visible beneath the Bankers Trust Building, which is under construction. Comparing this view to the construction photographs available in the Bankers Trust Virtual Archive on the Skyscraper Museum website narrows the date to June or July 1911.

Seven

St. Paul's

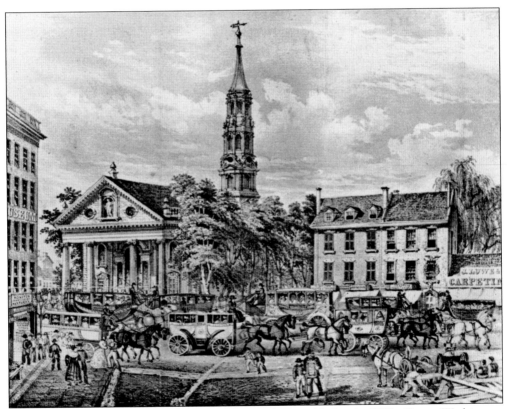

St. Paul's Chapel was built in the 1760s, and the steeple was added in the 1790s. George Washington worshipped here when the national capital was in New York. I.N. Phelps Stokes found this view "especially interesting as depicting the various types of stages in use at the period." This reprint was published in *Hemming's History of the New York Stock Exchange* (1905). The original lithograph was issued in 1832.

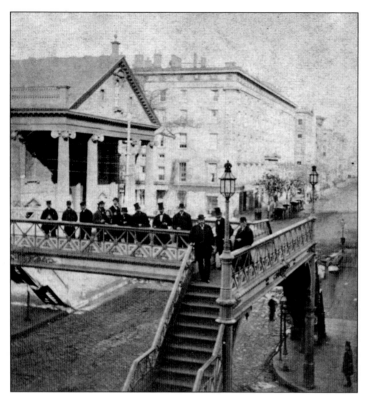

Crossing Broadway was a hazardous enterprise, so in 1866, the city, at the urging of Joseph Genin (Genin the Hatter), began work on a pedestrian bridge. Apart from supplying a safe crossing over Broadway, it proved to be a popular place to have one's picture taken. The people here are unidentified. St. Paul's Chapel and the Astor House can be seen in the background. But what seemed eminently sensible to Genin earned the opposition of his rival, Charles Knox. A court agreed and ordered the bridge to be taken down.

This photograph of the pedestrian bridge over Broadway was taken from ground level among the tombstones in St. Paul's churchyard.

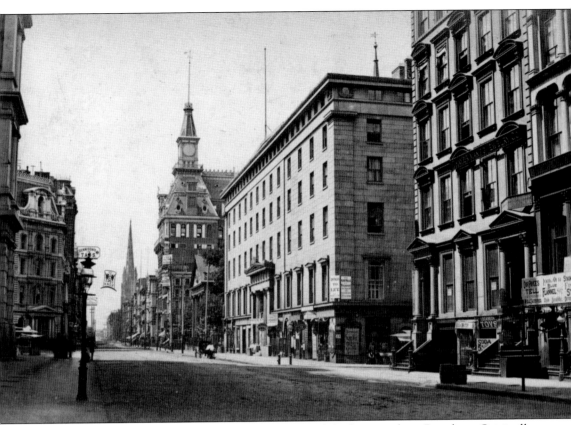

The Astor House is at the center of this 1874 photograph looking south on Broadway. Originally called the Park Hotel, it was designed by Isaiah Rogers and opened in 1836. Rogers had gained renown as the architect of the Tremont House in Boston and also designed the second Merchants' Exchange at 55 Wall Street. The Astor House was where Jenny Lind stayed when she was performing at Castle Garden, and in 1861, president-elect Abraham Lincoln gave a speech standing above the columns of the entrance. The portico of St. Paul's Chapel can be seen just south of the Astor House with the Western Union Building (architect George B. Post, 1875) beyond it. The spire of Trinity Church is in the distance. The advertising banners over Broadway are for Dennison's tags and Knox the Hatter. The building at the left with the mansard roof across from St. Paul's is the Herald Building, which was completed in 1867. The architect was John Kellum, who also designed the first New York Stock Exchange (see page 40).

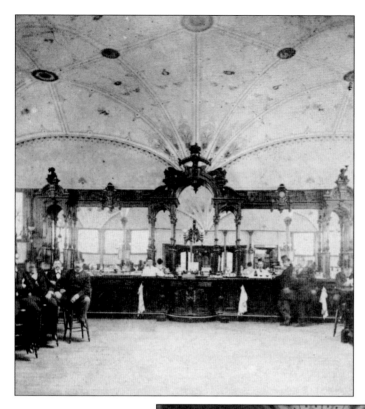

The Astor House was faced in granite, but James Bogardus, the pioneer of cast-iron architecture, had a role in its development when he enclosed the building's courtyard in 1852. The space became known as the Rotunda, which Moses King in *King's Handbook of New York City* (1892) described as "a much-frequented eating-place for noon-day meals." This photograph shows the ornate mahogany bar.

The Astor House Rotunda had two circular lunch counters, one of which is shown in this photograph. *Scientific American* commented the following in 1853: "The roof is a new feature in architecture; it is constructed on the suspension principle, having girders springing in graceful curved lines from post to post, uniting strength and lightness in a most ingenious manner." Both of these photographs of the Rotunda are from stereoviews.

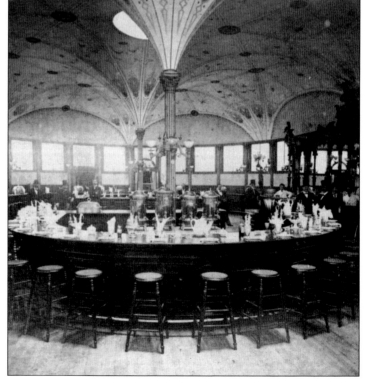

The National
Shoe and Leather
Bank built this
structure at the
southwest corner
of Broadway and
Chambers Street
in 1855. Today, the
name may sound
a bit humorous,
but the National
Shoe & Leather
Bank had its origins
in the leather
business. In the
19th century, banks
had names such as
the Importers' and
Traders' National
Bank, the Corn
Exchange Bank,
and the National
Butchers' and
Drovers' Bank.

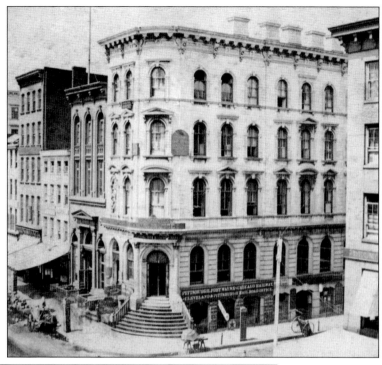

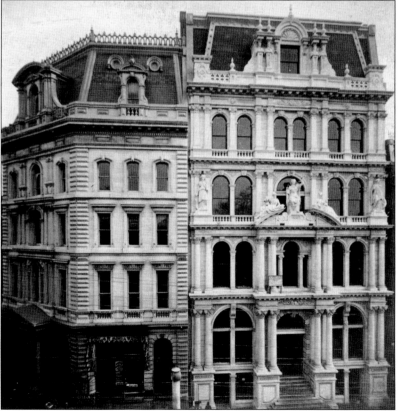

The National
Park Bank
Building (at
right) was
designed
by Griffith
Thomas and
was completed
in 1868. It was
next to the
Herald Building
(at left). Both
buildings have
mansard roofs
in the French
manner, but
Thomas's
design, complete
with statuary
at the third-
floor level and
caryatids on
the roof, took
Victorian bank
architecture to a
new and highly
ornate level.

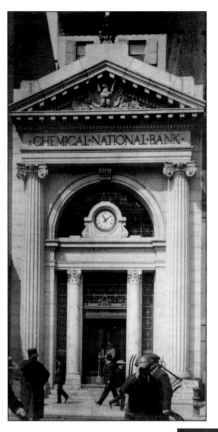

The New York Chemical Manufacturing Company was founded in 1823 and added a banking operation the following year. In 1844, the charter for the manufacturing company expired, and a new charter was obtained for the Chemical Bank. Trowbridge & Livingston designed this building at 270 Broadway that was just south of the National Shoe & Leather Bank. It was completed in 1907. The Chemical name lasted until its merger with Chase Manhattan in 1996.

This photograph shows two buildings under construction: the City Investing Building and, directly behind it, the tower of the Singer Building. To the right is the statuary on a cupola of the Park Row Building. The City Investing Building, designed by Francis H. Kimball, looked sprawling and ungainly compared to the graceful architecture of the Singer Building.

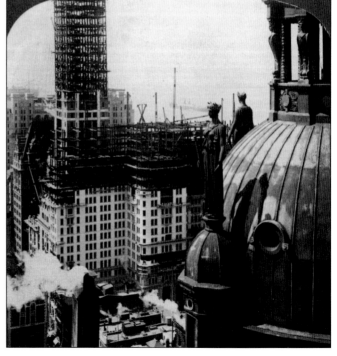

The Singer Building was constructed in two stages, both designed by Ernest Flagg. The earlier building was constructed between 1897 and 1899. The second phase, completed in 1908, expanded the base of the building to the north and added the tower. After six decades, the Singer Building and City Investing Building were replaced by the bluntly rectilinear design of 1 Liberty Plaza.

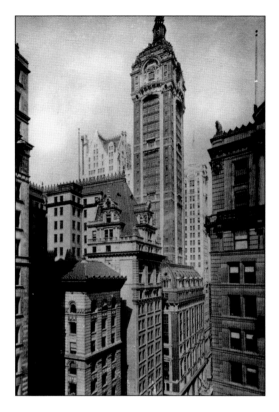

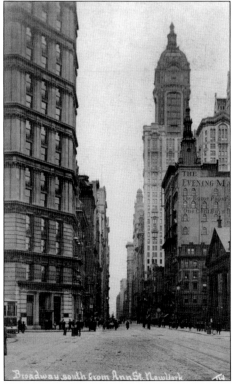

Following the *New York Herald*'s move to Herald Square, the St. Paul Building (at left) was constructed on the site of the old Herald Building. It was designed by George B. Post and was completed in 1899. In this Thaddeus Wilkerson real-photo postcard, the Singer Building is in the background.

A message on a postcard promoting the Singer Building touted the observation platform. Payment of 50¢ would obtain a view of 30 miles with "competent guides in attendance."

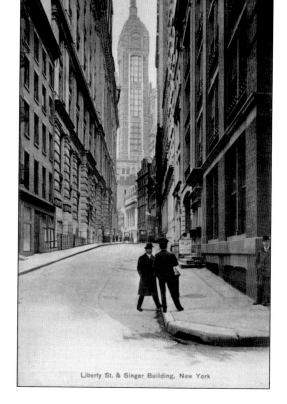

Liberty St. & Singer Building, New York

Liberty Street provides a dramatic vista for the Singer Building in this postcard view looking west. The Chamber of Commerce of the State of New York Building can be seen at the base of the Singer Building. To the left is the Mutual Life Insurance Company of New York. For another view of Liberty Street, see page 123.

The Statue of Liberty in the upper right provides a distant counterpoint to the Singer Building rising above the City Investing Building. The Whitehall Building is above and to the right of the Singer Building.

This postcard compared the height of the Singer Building to a variety of other structures, including Madison Square Garden (marked as No. 1 on the numbering key), St. Peter's Basilica (No. 3), Philadelphia City Hall (No. 7), the Washington Monument (No. 8), the City Investing Building (No. 9), St. Mark's Campanile (No. 10), the Great Pyramid of Giza (No. 11), Cologne Cathedral (No. 13), St. Isaac's Cathedral in St. Petersburg (No. 15), and Salisbury Cathedral (No. 16).

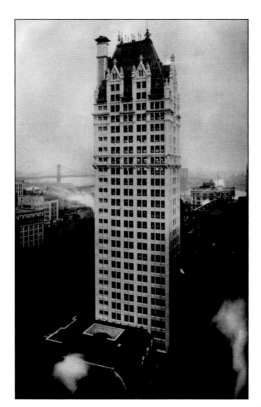

Liberty Tower at 55 Liberty Street was designed by Henry Ives Cobb and completed in 1910. Cobb skillfully wove together Gothic design and pure whimsy, including an entrance with terra-cotta alligators, on a building rising 33 stories. For many years the home of Sinclair Oil, Liberty Tower was converted to residential use by Joseph Pell Lombardi in 1979.

The Chamber of Commerce of the State of New York Building at 65 Liberty Street is an excellent example of the Beaux-Arts style. It was designed by James B. Baker and completed in 1901. Pres. Theodore Roosevelt spoke at the dedication ceremony. Because of deterioration, the marble statuary on the exterior of the building was removed in 1926. The chamber moved from the building in 1980, and it is now the New York branch of Taiwan-based Mega International Commercial Bank.

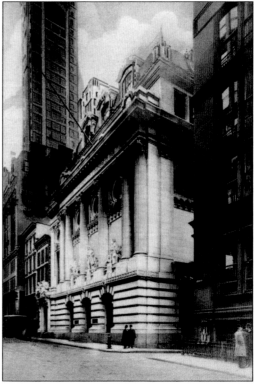

It does not look particularly canyon-like by today's standards, but this real-photo postcard looking east on Liberty Street is labeled "City Canyons." It shows the Federal Reserve Bank of New York at left and the Victorian facade of the Mutual Life Insurance Company of New York at right. The New York Fed was designed by York & Sawyer and was completed in 1924. The area currently across the street is the plaza of 1 Chase Manhattan Plaza.

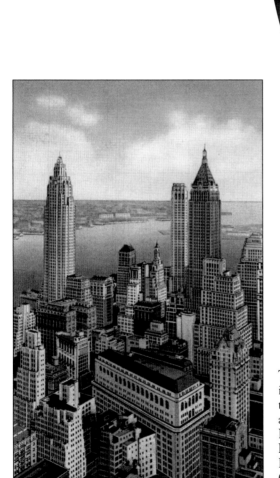

The Federal Reserve Bank of New York is in the foreground of this postcard. The three tallest buildings on the skyline are, from left to right, the Cities Service Building at 70 Pine Street, the City Bank Farmers Trust Building at 20 Exchange Place, and the Bank of the Manhattan Company Building at 40 Wall Street.

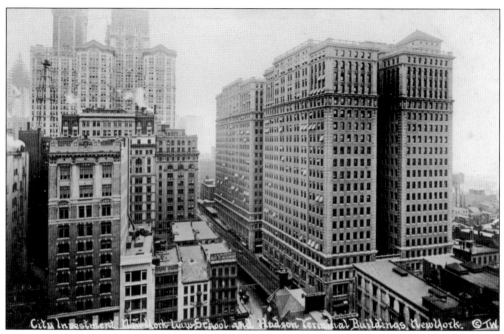

The Hudson Terminal Buildings, designed by Clinton & Russell and completed in 1909, are seen here at right. They were built on the site of what became the World Trade Center. In this Thaddeus Wilkerson real-photo postcard, the City Investing Building is at upper left.

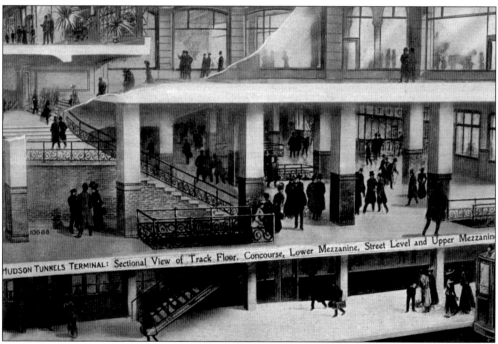

The Hudson Terminal Buildings had office space above ground. Below ground was access to trains linking New York and New Jersey using tunnels under the Hudson River. This cutaway view shows the tracks at the lowest level and the concourse one level up. Street level is seen at the upper right.

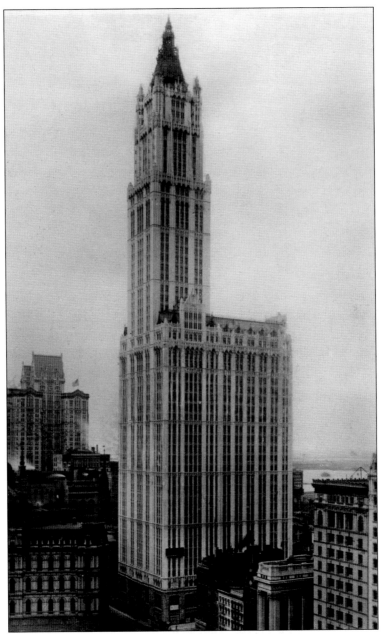

Frank W. Woolworth was planning on a smaller structure, but while on a trip to Europe, he found that people were talking about the Singer Building. That gave him the idea for a building that would serve as an advertisement for the Woolworth five-and-dime stores. In 1910, he hired Cass Gilbert, who had established his reputation with his design of the Minnesota State Capitol. In lower Manhattan, Gilbert had previously designed the US Custom House on Bowling Green and the West Street Building. Gilbert used terra-cotta for the exterior of his soaring version of Gothic architecture. The Woolworth Building rose 180 feet higher than the Singer Building and was the tallest structure in the world when it was completed in 1913. It remains one of the most recognizable buildings in the New York skyline. At the lower left of this real-photo postcard is the US Post Office and Courthouse that occupied the southern end of City Hall Park.

A promotional brochure published for visitors to the Woolworth Building had the title *Above the Clouds and Old New York*. In this real-photo postcard, the Woolworth Building lives up to its billing.

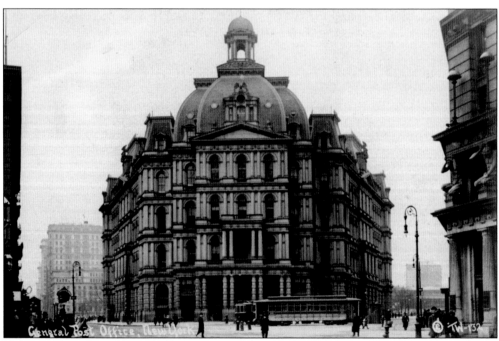

If the Woolworth Building could exist among the clouds, the US Post Office and Courthouse designed by Alfred B. Mullett was decidedly earthbound. In Washington, DC, Mullett had designed what is now known as the Eisenhower Executive Office Building, and he brought his characteristically heavy Victorian style to New York. After this building was torn down in 1939, the site was reclaimed for City Hall Park.

BIBLIOGRAPHY

Buck, James E., ed. *The New York Stock Exchange: The First 200 Years*. Essex, CT: Greenwich Publishing Group, 1992.

Burrows, Edwin G., and Mike Wallace. *Gotham: A History of New York City to 1898*. New York: Oxford University Press, 1999.

Devens, R.M. *Our First Century: Being a Popular Descriptive Portraiture of the One Hundred Great and Memorable Events of Perpetual Interest in the History of Our Country*. Springfield, MA: C.A. Nichols & Co., 1878.

Dunlap, David W. *On Broadway: A Journey Uptown Over Time*. New York: Rizzoli International Publications, 1990.

Engineering News. "Water-tight Caisson Foundations for the New York Stock Exchange." September 26, 1901.

Gabrielan, Randall. *New York City's Financial District in Vintage Postcards*. Charleston, SC: Arcadia Publishing, 2000.

Gayle, Margot, and Carol Gayle. *Cast-iron Architecture in America: The Significance of James Bogardus*. New York: W.W. Norton, 1998.

Gilder, Rodman. *The Battery*. Boston: Houghton Mifflin, 1936.

Hubert, Philip G., Jr. *The Merchants' National Bank of the City New York, 1803–1903*. New York: Merchants' National Bank, 1903.

Landau, Sarah Bradford, and Carl W. Condit. *Rise of the New York Skyscraper, 1865–1913*. New Haven, CT: Yale University Press, 1996.

Severini, Lois. *The Architecture of Finance: Early Wall Street*. Ann Arbor, MI: UMI Research Press, 1981.

Stern, Robert A.M., Gregory Gilmartin, and John Montague Massengale. *New York 1900: Metropolitan Architecture and Urbanism, 1890–1915*. New York: Rizzoli International Publications, 1983.

Stern, Robert A.M., Gregory Gilmartin, and Thomas Mellins. *New York 1930: Architecture and Urbanism between the Two World Wars*. New York: Rizzoli International Publications, 1987.

Stern, Robert A.M., Thomas Mellins, and David Fishman. *New York 1880: Architecture and Urbanism in the Gilded Age*. New York: Monacelli Press, 1999.

Stokes, I.N. Phelps. *The Iconography of Manhattan Island, 1498–1909*. 6 Vols. 1915–1928. Reprint, Union, NJ: Lawbook Exchange, 1998.

DISCOVER THOUSANDS OF LOCAL HISTORY BOOKS FEATURING MILLIONS OF VINTAGE IMAGES

Arcadia Publishing, the leading local history publisher in the United States, is committed to making history accessible and meaningful through publishing books that celebrate and preserve the heritage of America's people and places.

Find more books like this at
www.arcadiapublishing.com

Search for your hometown history, your old stomping grounds, and even your favorite sports team.

Consistent with our mission to preserve history on a local level, this book was printed in South Carolina on American-made paper and manufactured entirely in the United States. Products carrying the accredited Forest Stewardship Council (FSC) label are printed on 100 percent FSC-certified paper.

MADE IN THE USA